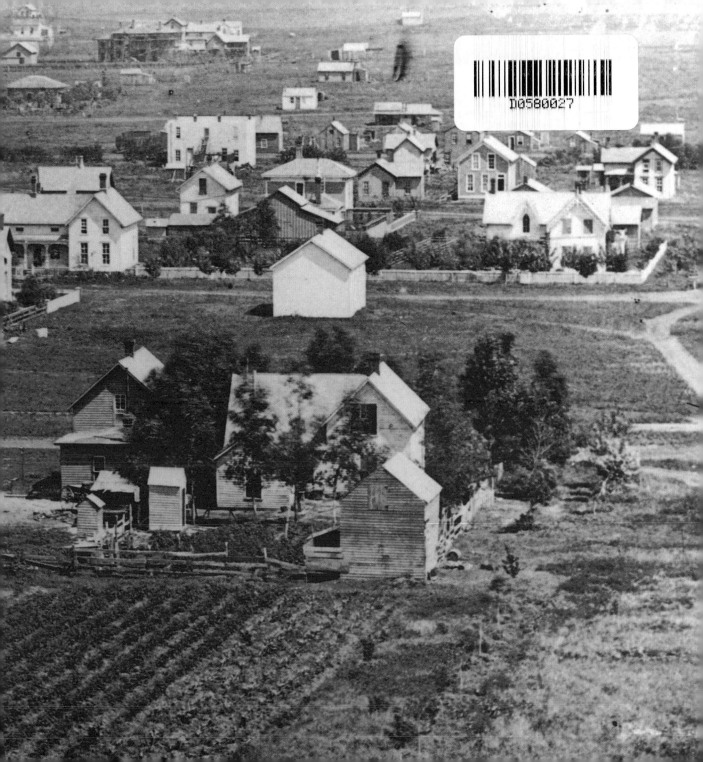

D0580027

Feels Like Home

Also by Cheryl Moch:

Deals (with Vincent Virga)
In Celebration of Babies (with Carol Tannenhauser)

FEELS LIKE
HOME

Edited by Cheryl Moch ❦ *with an introduction by Allan Gurganus*

Algonquin Books of Chapel Hill

1995

Published by

ALGONQUIN BOOKS OF CHAPEL HILL

Post Office Box 2225

Chapel Hill, North Carolina 27515-2225

a division of

WORKMAN PUBLISHING COMPANY, INC.

708 Broadway

New York, New York 10003

© 1995 by Cheryl Moch. All rights reserved.
Introduction, "Home in Time," by Allan Gurganus. © 1995 by
Allan Gurganus.
Printed in Italy.
Printed simultaneously in Canada by Thomas Allen & Son Limited.

Endsheets: Lincoln, Nebraska, 1875. Page i and 1: Rochester,
New York. Page iii: Brookline, Massachusetts. Page iv-v: Louisville,
Kentucky, 1921.

LIBRARY OF CONGRESS CATALOGING-IN-
PUBLICATION DATA
Moch, Cheryl.
 Feels like home / by Cheryl Moch ; with an introduction
 by Allan Gurganus.—1st ed.
 p. cm.
 Includes index.
 ISBN 1–56512–082–5
 1. Photography, Artistic. 2. Dwellings in art. I. Title.
TR654.M56 1995
779'.4—dc20
 95–3194
 CIP

10 9 8 7 6 5 4 3 2 1
First Edition

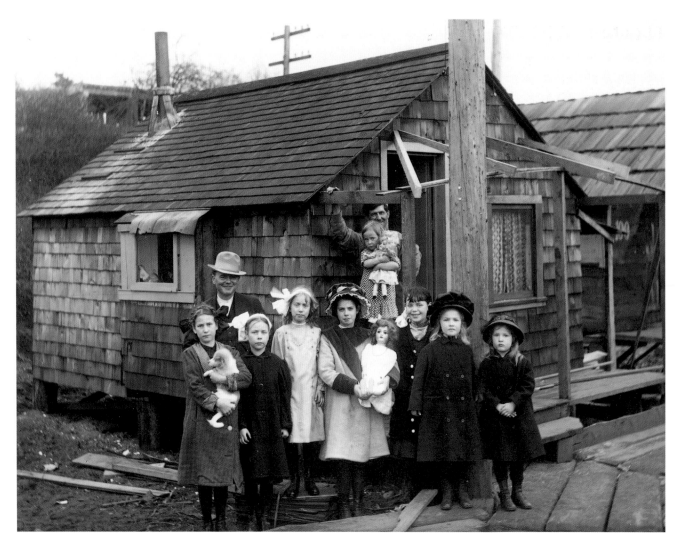

Seattle, Washington, circa 1910

HOME IN TIME

by Allan Gurganus

"Lucy, I'm ho-ome."—*Desi Arnaz*

Give any child of five a piece of blank white paper. Provide a new box of pointy crayons. Leave the kid alone for about three minutes. And that young artist—however scarily computer literate—will yet sketch for you The House. Our House.—Ninjas might be floating over it, black holes might now flog its little patch of sky, but these make the place feel more a Home, not less.

The house your child has drawn still shows familiar windows—wide-open as two trusting caffeinated eyes. Under a jaunty roof, its door is all smile. The whole place radiates the endearing, luminous personality of a hand-hacked jack-o'-lantern. Note the tulips lined on either side of it? See the smoke coiling out its chimney toward a grinning avuncular Sun.

The last time *I* remember seeing chimney smoke curl toward the sun was four years back in the Sierras. So, how are our post-modern kids *born* knowing this homey central mantra for meaning, curtained peace and human sweetness?

There is something quantum about the one roof, those few tables and chairs, the single bed on earth you judge as yours. Every human life accommodates one great, typifying love. And, for each of us, there can only be a single formative homeplace.

'Home' is less a concept, more a sensation. If it feels like home, it probably is. Where you park your backside, where you stuff your gullet, where you dress and bathe and pro-create, or not—a crucial decision has been made for you by that one holy word, my favorite of all—more visible than "soul," less overused and misapplied than "love."

The tinniest of Tin Pan Alley songs can tell you all "Home's" sentimental legends: It's more than mortar. There is, apparently, no place like it.

On the porch of my grandparents' white Victorian, the family gathered each Sunday. Attendance: mandatory. We swarmed in from cushy suburban houses with golf-course views. My father and his brothers claimed the best chairs surrounding their parents' throne-sized rockers. By now, the vista from the porch offered little more than a grammar school yard—but these tall young men rocked back like Lords.

Returned to 'the old part of town,' they surveyed the world with a sense of sovereign ownership, a strange relief rarely felt in their far-flung exurbs of crabgrass and mort-gages. They'd grown up here; their sudden ease showed this. We kids piled onto them, enjoying their sudden boy-ishness—they sounded loud, brash, golden and convexly male as young trombones. They looked kinder, plumper, younger in the presence of their parents, in the lap of their ancestral porch.

I am an American and a Southerner, though not nec-essarily in that order. Far-westerners may idealize their picture-book Ranches. Native Manhattanites rightly revere their inherited pre-war Brownstones. But perhaps

no American region feels more romantically disposed toward Homeplace than do we on the Mason-Dixon's sub-equatorial slope. (Even the lovely word "home-place" tells us that a Southern house must have some land, some 'place' around it; land and domicile, being equally holy, get to intermarry in one word.)

The Southern homeplace is more valued for having been so often lost. Southern Worship of the ancestral seat is, like Christianity itself, invented around a central, echoing missingness.—Sherman came and burned the homeplace. Or, poor Daddy lost it at cards. Or, new-here Yankee bankers took a shine to that fine columned portico and 'wrastled it away from us'.

The longer your homeplace stays in strangers' hands, the more memory expands its acreage; the drippier grows its Spanish moss; the happier were its servants (formerly known as "slaves"); the more genteel were its ladies— their hoopskirts mystical in beauty as Saturn's rings.

As with innocence, you know 'Home' best right after someone's gone and got yours away from you. But, like innocence itself, you might discover in old age that you never really lost the plantation after all; not if you can remember it. Nabokov, whose own immense Russian landholding was sacrificed to the People's Revolution, states it simply: "Memory is the only real estate."

In a Southland where the Federal Army shrewdly sought victory by burning most of our significant civic and private structures, the cause called Homeplace—lost or found—became Religion.

*M*y own family—white, proud, land-poor— rented, but only to others. We prided ourselves on our properties' order, symmetry, and steady painted-ness. Tulips counted. Porchsteps were swept daily. Even during hurricanes. (There is a dubious family tale about one admired household servant who tied a rope around herself and thus secured her body to porchrailings so her broom could purge from our porch riffraff palm fronds blown clear from Florida.)

There was only one paint shade suitable for coating any establishment belonging to Whites: White itself. Your shutters had to be green, or—if you wanted to risk being labeled Bohemian—they could go so far as maroon. But anyone who'd paint his shutters coral-colored or 'aqua' would also place a plaster flamingo in his yard. He could not expect to get around the Country Club's Membership Committee. He was also highly unlikely to find Paradise. Such a scoundrel would probably ride some motorcycle around town, shirtless. For the middle class, Paradise will always have something to do with assured property values.

I've spent much of my adult life in the North. Yankee friends assume that only the South's landed gentry enjoys this comic passion for Homeplace. That is just not true. Family holdings need not be epic to be valued; they need only be valued to seem epic. One vain, compulsive hometown gardener was often described as "A legend in his own yard." Everybody is. Hence the popularity of yards.

Our family station wagon once broke down in a far-away Carolina city after 11 P.M., and in its "Colored Town." No public phone could be found. In the South's 1959 Apartheid, this was a white lady's worst fear. To complicate things further, my mother had been driving home from the beach, her four little sons sleeping in back. "Now which of these houses do we turn to for help, my young Sherlocks?" She engaged us, calmed us. She waited till, evidence offered, we groggily picked the very one she'd chosen before waking us.

First she pointed out which line was a phone line and how few homes here were rigged with those, rather cru-

cial tonight. Most houses in sight looked blasted, bare, dangerous—rentals.

Now, when bad things overtake nice folks—across all boundaries of race and class—owners seek owners. You can quote me. This is a fact I possess along with one house and a good Ford car.

The residents we would soon wake had left telltale signs: they'd gone and re-enameled their porch glider, now seen gleaming by streetlamp's light. Flower boxes abounded. A tasteful cement Jesus (exceptional omen) showed moon-flowers growing up his robes but not on his face. One auto tire, flat to dirt, painted white, sprouted a giddy volcano of purple petunias, fragrant even near midnight.

After Mom's three short determined blows at their locked screen door came the blast of a hundred-watt yellow porchlight. Then, wearing haircurlers and pajamas, fellow homeowners offered us a gruff kindness that *so* reassured. (Mother still sends them Christmas cards.)

Certain Home Truths live forever uncontested: You must leave a home to know you ever really had one. It helps, returning to your homeplace sick or divorced or broke; that way you truly feel the tender stretch of home's reaching out, its re-enfolding you. Coming back changed, you find that home has stayed essentially the same. Surely, that's what it's there for—a bulwark from bad weather, a hushed rest-stop from time. And, Grounds for comparisons—*your* grounds.

House-proud" remains, along with weak lungs, my family's inborn disease. I was five when they first took me to meet my Great-Aunt Nina. She was onto ninety, confined to a Presbyterian retirement home. A small, sociable woman, she had owned a good large house—if not a great one. My parents coached me, in advance: whenever poor Nina suggested that we carry all our tea-things "to the West Parlor, where the light is so much prettier this time of evening," we should convince her to stay put. (There was, of course, no longer a West Parlor. There was only this, her room the size of your average motel's 'single'.) It was the first time I had ever been enlisted in a social conspiracy; it would not be the last. And so, tense with an inborn Southern gallantry, eager to spare the old lady's feelings, hoping to protect her from her demeaned whereabouts, her whittled time, I joined the adults.

As usual, I overdid. No sooner had Nina exclaimed, "But whatever am I *thinking* of? forcing my own family to sit in a dingy sideroom when—this time of day and year—the light's all but golden overlooking the church-yard from our West parlor," I jumped up and swore that nothing on Planet Earth could ever possibly be more pleasant than our current squat, ignoble cubicle. Seeing her try a feeble rising from her rocker, I was forced into paroxysms of praise for this cell, its doilied furnishings, even its color—the soul-killing green of a junior high school bathroom.

Soon, behind the old lady, my parents were making faces and shaking their heads No. But I couldn't stop. I kept pointing out every drawerpull's beauty. Nina, re-settled, seemed to enjoy my little show. Adults used the diversion, shifting conversation back to safer topics: Cancer in cousins, Politics, Crop allotments, and which neighbor had fallen off the wagon yet again. "It's Cancer of the *Tongue*, they say."

But I heard little of their chat: What I recall is the tension of trying to deceive a clever person into believing she is Home when she is not.

During the long car ride back to our own house, I slept, exhausted by the scope of that first lie. Either you are home or you are not. All kids of five know this. They can draw it for you.

*M*y family's less-than-pretty prejudices spring from a zeal toward ownership, their obsessive love of houses (mainly their own). 'Who needs to vacation when we've got a porch this fine?'

Any undergraduate can tell you "Property Is Theft." This remains true till the very second you learn that Grannie unexpectedly left the Homeplace to you, her college radical. Then Property overnight becomes a mission in history, recovery, restitution, meaning. Suddenly, Theft is Property . . . Tax.

I own up: my biases lushly spring from the flinty rental soil of Protestant acquisitiveness and small-town pride. And I admit 'Trash' is never a pretty term, especially when applied to human beings. A Harvard-educated African-American friend of mine recently visited from the North; his luggage had not yet ridden Raleigh-Durham Airport's carousel before he was scolding me. I was Politically Incorrect. See, I'd used the phrase "White Trash." Odd, I never say that in New York City.

Nothing human should be considered garbage, true. Of course, racial categorizing is wrong. All this, I readily concede. White liberals who enjoy the love of black friends feel especially wounded by charges of reckless terminology. Lenny Bruce claimed, "Liberals can understand anybody, except anybody who can't understand Liberals." I cringed at my old friend's accusation. And maybe I was overeager to justify myself. But I soon recalled that my pal here, so quick to denounce me as rearguard, allowed himself certain retro-moments. When 'hanging' with his African-American pals, he often jokingly and fondly used the N-word. Didn't this give me license to distinguish (and possibly even impugn) some of my own more distant pallid kinsmen? Do I sound defensive? I felt that way.

Since we were in North Carolina—where I'd learned this ruthless "W. T." term from my bitterly house-proud family—I simply drove my pal (call it research both

ethnographic and ethical) deep into the wilds of hardscrabble farm country way way down east.

The more 5 mph tractors we passed, the quieter he grew. He studied stucco bunkers marked "New and Used Weapons for the Whole Family." Many 'Deer Crossing' signs—yellow diamonds with prancing antlered bucks in silhouette—were apparently just asking for it. Bullet holes had turned steel to lace then porthole.

We watched billboards devolve into homemade placards. Around about Bailey, N.C., the spelling started to slip. Soon—except for farm stands' tomato prices—commercial signage abated. Only hand-painted mottoes accosted us: "Let Us of 'Red's Taxidermy' Stuff That Prize Deer/Bear You Bagged This Saeson." "Get Rite With God Or Else." The silences between us lengthened; we sensed we were a black man and a white man in one car, and both in the front seat.

I'd once visited South Africa's townships, making sure to keep my gentle black guide close close by. Now, my friend was braving the Piedmont sandhills in search of a creature he believed to be some unicorn concocted by my repressive white-ruling-class imagination. I started getting scared out here myself. I felt the latent bigotry of his bigotry toward my bigotry. Is this too much?

I parked along a ditchbank between two farmhouses chosen at random: yet it seemed I was keeping an appointment made long ago. I spared my friend any of my usual small-town Greek-chorus commentary. I still don't know what he made of what I showed him. I do, however, remember precisely what we saw: two visions of how to "Home" (a verb).

On our left, one small white farmhouse appeared designed by a short and tidy architect named Bill Smith or Mike Brown, some guy armed only with ideals and Crayolas, plus that nifty sharpener built right into the box. Shaded by giant oaks, the tin-roofed house rested on four

brick pilings. Their mortar had been painted very white, their red bricks rouged—by a small brush—even redder.

One old farmer, white and pink and brick-tinted himself, had nearly finished sweeping the half-acre yard. His broom was home-bound privet branches. Any grass had long since been scratched to death. Dirt was packed so tight, was smoothed so often, Planet Earth had been worn silver.

One goodly breeze moved Dotted-Swiss curtains fluffing every window. Potted plants, flowering pastel, overhung the porch railing and, even from here, you could tell which white wicker rocker was hers, which squat red one his.

The presumed wife of the old guy sweeping gardened in a trance. Head bound in rag, wearing gloves and a sun visor, she looked like some human cleaning instrument/bottle plunger. She knelt on a burlap feedsack. Spread across the sack adjacent: her clean tools, and one copper watering can that'd bring four hundred dollars in any chichi shop north of Baltimore.

She worked three rows of dahlias, staking up flowers so tall and brilliantly crayon-waxy they seemed either stage-props or carnivorous. Splints—supporting each flower—were new pine staubs tied with white rags long enough to form a goodly kite-tail. The trusses gave each blossom the noble air of someone being crucified in traction.

Ancient pin oaks shaded the tin-roof. Tree trunks had been white-washed five feet up. Paint gave these massive trees an air—less of wearing Fred Astaire's spats—more of being good elephants bound for church on Easter, all sporting white-wall tires as anklets. The whole farm, its useful outbuildings and happy implements, had the feel of a 4-H calendar come to blue-ribbon life. These folks might've been my grandparents' third cousins twice removed. Trash? No, the friction-resisting rituals of health, diligence, and cleanliness had been practiced here so long, even the trees aspired to having baseboards.

This home stood to the left of our parked car. Now, we swiveled right. Seeing what awaited us, my pal half-consciously locked his car door. Unpainted, the other place proved harder to assess or assemble in one glance.

I will say: It utterly lacked tulips. Compared to the neighboring farmhouse, it seemed located several nations nearer the Tropics. We studied nine trashed cars dragged into a weed-tangled foreyard. Two chickens occupied the front seat of one former-Buick; they sat facing forward as if navigating. An open field stretched behind the house, and you might wonder why such metal hulks had not been towed back there. Then you realized that—even sans axles, sans wheels or roofs—these were still recognizably automotive, possessions of some weight. You slowly understood they were displayed with pride.

We studied discarded oilcans, a constellation of jagged broken glass, a small sour campfire burned unattended. The leaking porch sagged with appliances that seemed placed out there as snacks for rust.

We did a head count of mostly naked blond children, dirt-colored. Four boys stood whipping one little girl, using a tree limb; but her screams did not distract the young-old mother who sat chain-smoking, looking at the horizon, drying her yellow hair by hand, holding it out in slow handsful toward the sun. The presumed patriarch eventually came clear as that pair of oil-stained pantlegs sticking out from under the one pick-up truck with four tires. But the legs' continuous stillness hinted that all repairs had ceased, thanks to the mechanic's death or sleeping.

I allowed my Northern friend to witness this circus of litter, Caucasian slack, and septic seepage. Then, glancing back at dahlias, we drove off. He finally spoke first, sounding winded and—if not chastened—then confused, "Let's go get a beer, if they've even invented that out here."

The tight-lipped satisfaction I felt at this lucky contrast shamed me, it did. I couldn't quite articulate what each roadside home represented. Ancient standards stirred in me. I felt uneasily reminded of tintypes showing my own lipless great-grandparents—faces as 'cured' as hams, by work and church. I felt in sudden touch with kinfolk I'd once considered only reactionary.

My visitor from the North was the great-great-grandson of slaves. His parents had prospered in Washington, had attended Ivy League schools. They'd passed along to him a sense of entitlement that meant defending all those less fortunate than themselves. He could be idealistic about the public schools precisely because he had attended St. Albans. Visiting the South for a weekend, he felt obliged to teach.

What he failed to understand was, precisely, my own history. What he failed to know was the exhaustion of people like my father's tribe, trying to 'keep things nice', a pride always underwritten by panic. Panic of falling behind in the payments, of losing face, of failing your own kids after instilling them with standards too high, panic of regressing in an America that preached Progress through Work. There was, therefore, the sad daily rage: living alongside others who—though outwardly, visibly like oneself—refuse to bother to even seem to try.

I've seen the same uneasiness from African-American church ladies, all in white, walking toward church, wound within veils, testing white high heels, holding white cookbook-sized Bibles, Sisters wrapped in cologne and chatter and an air of ferocious, beautiful righteousness. Then they hush, then—as one—they cross the street to avoid an oncoming woman of their own age and class—if not quite their weight—someone caught returning home very late from an over-popular Saturday night. Her dress is bright, her makeup looks a little overutilized. The Church Ladies might forgive her if she lived anywhere else and if she looked like anybody but themselves, if she hadn't attended school with them and gone and got her history (and street) all tangled up with theirs. Pressed white dresses, still smelling of Niagara spray starch and steamed sanctity, confront a red dress stinking of cigarettes and worse—a dress that looks slept in.

'Home' inspires defense. 'Home' invokes an ethical and spiritual address.

Like those choir members wearing hard-won white, my forebears denied anyone's right to a passivity inspired by generations of grinding poverty. "They don't keep their place nice": this was not a judgment on the scale or grandeur of the homeplace itself, only the fervor of its maintenance. For such people as mine, Home remained the single standard. Home stayed both our whip and our goal; it was the jail of choice, offering all there was of comfort. Home meant a portrait of you—one repainted, by your own broom, every single day.

*M*y own grannie loved red tulips: that's all I'm saying. Though most tulips bloom for you just once a year, and though planting a hundred of them can sometimes prove joyless as car washing, still, you *did it.* If only to prove that you were respectable. Your schoolbound children left your house scrubbed so clean they whimpered, touching their necks soap-burned with pink stripes. If your kids' starched collars chafed up a few blisters, well, so much the better; nobody could say you hadn't tried.

Your household was an orgy only of organization. This is the unsentimental side of Home in the Protestant South; the lye side, the bleached side, the Purgation of Satan's dinge and dust. Your house's 'being spanking clean' *implied* spanking. A good rug is a beaten rug. You know it's Order by how much it hurts.

We were not, as the Lord's creatures, guaranteed daily

visible Godliness. But Cleanliness is something you can work at. "How expensive is soap, after all? and you give some people a bathtub, they'll store their coal in it."

Such punishing folklore made the worst judgment against others: What—my grandparents asked and answered from their porch—what was the difference between riffraff and 'quality'? Riffraff didn't know what Home was. They made no connection between who they were and where they stayed. They were oblivious to how their homeplace looked and what it told of their history and essence, their future. Such rootlessness meant shift-lessness meant living a purgatory that—worst of all—*was visible from the road*!

 .

As the twentieth century ends, as its car alarms and terminal insomnias subside, perhaps our age will be best described by a single tragic word. That word means "clueless," "history-less," "wandering companionless out-of-doors." That word means "Deprived of a daily mainte-nance called Self-Knowledge."

The Twentieth Century Was **Homeless.**

May the Twenty-first Century, like the Prodigal Son, refind its starting place. It ran away in quest of foreign settings, easy living, selfish sensation. May our next century return to its old order, refind its own first folks, resume its rights and houseplants, glorying in duty's very joys. Let's hope the Twenty-first—after a hundred years' wandering the wilderness of refugee rags and moral amnesia—at last comes Home.

 . . .

I end by offering a story someone told me at a party just three hours back. I guess that's why I go to par-ties. My friend sells historic homes. Only someone who grew up in the transience of Miami's art deco can feel such devotion to the permanence of eighteenth-century architecture. She has found a lot of it still standing in North Carolina. Our state is too poor to pull down architectural eyesores. Finally, styles shifting, such old houses regain glory.

My friend's kinfolks hail from Kentucky. Her family's pride was a thirty-four-room land-grant house with a bluegrass vista, one costly serpentine brick wall, and a history nearly as long as our nation's. Her great-uncle was named Grover Cleveland Blaydes. He was born dur-ing the 1880s, as his name suggests. He grew up in this grand Georgian House. There were early hints of finan-cial trouble. The 1709 English grandfather clock stopped clicking and nobody could afford to fix it; then it disap-peared . . . almost—if you didn't know better—as if pawned (for bread money). The homeplace had been awarded to ancestors so long dead no one still had time to count their exact number of prefix 'great's. Only young Grover knew their complete names and dates by heart. The fine brick house, the family seat, proved, alas, the house that Grover's parents lost.

No one's fault really. Four bad years of drought, a few generations' regrettable gambling, one unscrupulous banker—this is how our history gets away from us. No, not our 'history.' For that—if we choose—we always get to keep; but our property, yes.

The homeplace was sold to pretend-aristocrats. Given the place's grand looks, that could be expected. But what made it far worse—these pretend-aristocrats were *out-of-staters!*

Grover Cleveland Blaydes had just turned sixteen. His shamefaced family moved into Shelbyville, Kentucky, demoted twice: to being cityfolks, then renters. There was no money for college now that Grover, their youngest, came of age. So they sent him to work in the post office. He was given rural routes. No one felt real proud of this,

least of all young Grover—the family dandy, the family genealogist. But, despite his mere postal salary, Grover Cleveland Blaydes soon found an enriching wisdom. It came from knowing what he loved; which can—in the dispossessed South—come from feeling what you miss most.

I mean, he commenced to save. With his fussy vest and watch chain, his hair parted down the center like some person far older, Grover seemed born into the wrong time, born to be a bachelor. Here was a man too pure and high-strung for the usual lawyering and procreation. But he had certainly not been born to live in a single rented room ("Gentlemen Guests' Weekday Evening Meals Included"). Grover sacrificed. And, within a few decades of obsessive scrimping, he'd put together funds enough to start rebuying the great forfeited house. How much this cost him—in daily personal pleasures (the only kind)—I cannot reckon.

How long he'd been saving for the homeplace, no one knew. One afternoon, he simply walked into a real-estate office carrying three old shoeboxes stacked with bills in rubberbands. And he bought the place back.

He devoted himself to rearing hogs out there for supplemental funds. Grover C. Blaydes eventually started inviting relations for longish visits to the mammoth place. A silent, factual person, he simply set about the restoration. Doing so, he restored the family, meaning its own leveraged pride. When they lost the house, everybody had scattered and, after centuries of standing out, they'd tried a quick, shamed, blending in. Now, there was someplace to stand, a Homeplace.

Grover wrote letters to every second cousin who'd ever inherited any stick of furniture, every single spoon original to the house. If they didn't cooperate, he sicced their own richest eldest siblings (and executors) on them. Over time, he did much of the fixing-up himself. If he had not been born 'handy', gathering outrageously expensive bids

for roof repairs had made him so. The eccentric, beloved uncle lived out there alone, doing plumbing repairs in his vest and watch chain and the high, black lace-up boots that made him seem antique (and therefore as suddenly valuable) as the house itself.

The lost furniture—summoned home—returned, up ramps, in pairs, like beasts regaining the ark.

Soon Grover even found the broken, absconded grandfather clock. (He finagled it from a storeroom in the furniture museum some Duponts had founded in Delaware; retrieving it proved as diplomatically complex as getting your favorite nephew out of a Turkish jail, where he'd been sent for selling heroin to the prime-minister's nine-year-old daughter.) Home came the clock—with those mysterious extra dials—showing painted schooners and smiling moons—set like moles in its great round face. The nine-foot casing—half-steeple, part-coffin—lorded it over the foyer again. Repairmen made a housecall clear from New York City. No telling how many foregone postal holidays all this cost the aging Grover Cleveland Blaydes.

The homeplace clock soon gonged the hour, sounding lordly, musty, Lord-High-Executioner. It had a Gilbert-and-Sullivan comic stance, and much of their operettas' honey-colored innocence and brown-varnish swagger. Nobody had noticed actually missing the clock; nobody but Grover. Not a single of its Westminster chimings had been heard in over forty-seven years.

Grover asked all his dispersed siblings to arrive one Sunday right at noon. He arranged it so—just as the old clock sounded forth its twelve full gongs again—Grover might stand watching the faces of his loved ones register the return of the homeplace's lost timepiece.

Q: Are domiciles built primarily as art forms or as shelter from the elements?

A: As artful shelter from the elements.

Q: What is the most complex and dangerous of these elements?

A: It isn't rain or wind. It's Time. A house intends, above all else, to shelter us from time. No castle can.

This high-noon drama, this situation-making, seemed unlike Grover. He was Presbyterian by training, workmanlike in colorlessness; his was a noncomplaining predestined disposition.

But now, Grover, over eighty, seemed in a hurry for sensations. Came the proper Sunday, 11:58 A.M. Cars were heard on the circular gravel drive. In scuffed a few of his kid sisters, sporting canes. Into the great hall eddied all the old ones—men and women—formerly boys, formerly girls. Exactly as planned, one Prodigal clock, hidden from view in the stairwell's curve, chimed forth the surprise, in full voice. Grover studied his siblings. And all of them cried out. Some nervous men laughed after, trying to take it back. You can't. Several hands got clamped over mouths. "Oh Gro-ver! Where ever did you *find* it? Where had it got off to?"

Then they gathered around, an aluminum walker here, one gallant elbow supporting a rickety sister's arm. Some touched the clock's rosewood-boxwood inlay showing the points of a compass. All stared, childlike, at the Chippendale railing high above. (Rumor always claimed that this very foyer was designed in 1709 around this very clock.)

Grover's kin were suddenly beginning sentences they did not—and need not—finish. "Remember the time Mother tried on the . . . ?" followed by nods. "And then that other time when Aunt Sally . . . at Halloween?" "And with the chicken?" Others nodded. "The time that . . . the time the fancy cousins came out from Louisville only to discover that we wild things didn't even . . ."

It was this tick-tock two-word phrase the elder

Blaydeses heard echoing up their spiraling stairwell: *"the time, the time . . ."*

"Time" holds the lease on the homeplace; it regularly evicts. However 'landed' we transients claim to be, graveyards land *us* soon enough. The home. The Time. The Home in Time. Seconds computed in a House made only of decades, only of centuries. The fact is: we all rent. The fetish to believe we *own*, anything—is superstition. Home is a necessary lyrical fiction meant to briefly simulate permanence. In our terminal twentieth century's chaos, the grounds for comparisons are mined. The safety of a home means even more.

Grover, hiding behind the stairs, was grinning so, his face wet, pressed against one interior wall of the house he'd saved. He stood nodding, rhythmic as some basemetal pendulum that keeps the subtler workings running above, that keeps the telling going, the telling, of time.

Surely the luckiest among us—for however short a span—get to feel we've made it Home In Time.

*F*or nearly fifty years, Uncle Grover occupied the house he'd saved—saved for himself? for history? for others? for honor? For 'all the above', and for all the ancestors above.

Grover, quiet in his pleasure, loved to stock these rooms with weekend kinfolks and their curly, noisy children. Once the homeplace seemed nearly rejuvenated, once people ceased to even hear the veteran clock's steadying habits, Grover Cleveland Blaydes began the inevitable failing.

It's a comfort that a house can last twelve human generations; yet it's also a tragedy that a life-expectancy and a house-expectancy cannot be the same.—Maybe one of Grover's young relatives arrived to find him, eighty-six, dressed formally, clambering along the third-story roof, trying to nail down a storm-torn shingle. Maybe Grover

fell the usual number of falls expected from someone his age. He refused to have a non-relation live with him as caretaker. Everyone not joined to him by blood now seemed to Grover a stranger with designs on the house; perhaps the obverse of achievement is paranoia? Soon the family went into the kind of huddles families do best, and probably too often.

It was decided: "The Homeplace is just 'too much house' for Grover in his dotage." While all his judges had been bearing their own kids and polishing their careers, Grover had saved, then bought, then moved out here alone. True, he'd redeemed and regained the family honor. True, the place he'd spared now found its way onto the photographic Christmas cards of kin who'd never spent a cent to repoint a single of the mansion's bricks. True, Uncle Grover would now deed it to someone of the blood. Yes, he'd performed a great and heroic service to the family line. But Grover was becoming a danger to himself and to the hallowed place itself. Fire, imagine a fire here! One faction felt he should be allowed to die, as he'd lived, this far into the countryside. But reason and good sense—and the economics of it—these won out, as usual.

So, treated like the child we all, in time, become, Grover was told in those gushy over-loud tones certain unwise adults reserve for children, he could expect a great new adventure—his retirement, back in town!

He could bring some of the furniture he'd salvaged through pleas and bullying. And wouldn't this be fun? He could take a few good things to a perfectly charming rest home just twelve miles away from the big house itself.

He chose the three best pieces. Who would know these better? A great fuss was made as Grover unpacked on his first day in the clean, claustrophobic rest facility. Its low hallways were painted the gory yellow of egg yolks (Cheery!). Kids' crayon drawings of chain-smoking bug-eyed cottages had been taped up everywhere, spiky with suns. Construction-paper tulips were pinned to the announcement: "Don't Forget Your 3 P.M. Samba Lesson, Gang!" Grover appeared unamused.

*I*t was the very next morning. It should have been Grover Cleveland Blaydes' first full day away from his homeplace. It would've been the first dawn-to-dusk in half a century he had not studied daylight moving through the familiar high-ceilinged rooms, rooms formed as if the house were a specific trap meant to entice and enhance daylight's general beauties. It should have been his first day free of making meals himself, free from all the chores and clock-windings a great homeplace requires of the one person who's chosen to live there and remain accountable.

But at 7 A.M., in the residence of Uncle Grover's next-of-kin, came a jangled phone call from the director of the old-age facility. The man still sounded half-asleep. "I'm afraid I have some news. I'm afraid it's about your Uncle. I have to say up front I'm deeply troubled by this. And I assure you that what's happened is not my people's fault. Your Uncle is gone. The morning nurse found that your Uncle Grover had taken his pocketwatch, his housekeys, and he's just gone, apparently only in his robe, pajamas, and slippers. We've looked absolutely everywhere. I do so wish the weather were warmer. He seems to have set out on foot. Probably some time right after dawn. Near as we can tell—your Uncle's headed overland, mainly through the woods. It looks to us like he's walking the full twelve miles home. Shall we go after him? Should I just park in front of your family's homeplace and wait till he shows up? Could be—by this time—he's home already.—But, please just tell me what to do for him now."

There was a pause, a mumbled conference.

"Let him go."

Feels Like Home

*"Home is the centre
and circumference, the start
and the finish, of most of
our lives . . ."*

West Seattle, Washington, 1926

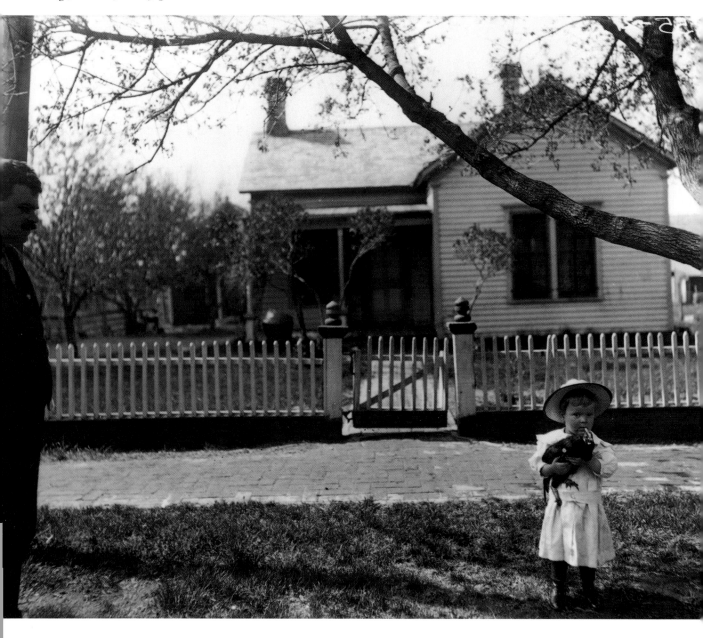

Neligh, Nebraska, circa 1905

The home is the centre and circum-ference, the start and the finish, of most of our lives. We love it with a love older than the human race. We reverence it with the blind obei-sance of those crouching centuries when its cult began. We cling to it with the tenacity of every inmost, oldest instinct of our animal natures, and with the enthusiasm of every latest word in the unbroken chant of ado-ration which we have sung to it since first we learned to praise.

—*from* THE HOME *by Charlotte Perkins Gilman*

We could never have loved the earth so well if we had had no childhood in it— if it were not the earth where the same flowers come up again every spring that we used to gather with our tiny fin-gers as we sat lisping to ourselves on the grass . . . What novelty is worth that sweet monotony where everything is known, and *loved* because it is known?

—*from* THE MILL ON THE FLOSS *by George Eliot*

Los Angeles, California, 1950

*A*ll the years we lived in that house where we children were born, the same people lived in the other houses on our street too. People changed through the arithmetic of birth, marriage and death, but not by going away. So families just accrued stories, which through the fullness of time, in those times, their own lives made. And I grew up in those.

—*from* "THE LITTLE STORE" *by Eudora Welty*

Black River, Wisconsin, circa 1895

Neligh, Nebraska, circa 1910

Before any choice, there is this place which we have not chosen, where the very foundation of our earthly existence and human condition establishes itself. We can change places, move, but this is still to look for a place, for this we need as a base to set down Being and to realise our possibilities—a *here* from which the world discloses itself, a *there* to which we can go.

—*from* MANKIND AND THE EARTH *by Eric Dardel*

7

Milwaukee, Wisconsin, 1900

*H*ome,—the nursery of the infinite.

— *from* NOTE-BOOK: CHILDREN *by William Ellery Channing*

*T*here was a world outside my window and contiguous to it. If I was so all-fired bright, as my parents, who had patently no basis for comparison, seemed to think, why did I have to keep learning this same thing over and over? For I had learned it a summer ago, when men with jack-hammers broke up Edgerton Avenue. I had watched them from the yard . . . When I lay to nap, I listened. One restless afternoon I connected the new noise in my bedroom with the jack-hammer men I had been seeing outside. I understood abruptly that these worlds met, the outside and the inside. I traveled the route in my mind: You walked downstairs from here, and outside from downstairs. "Outside," then, was conceivably just beyond my windows. It was the same world I reached by going out the front or the back door.

—*from* AN AMERICAN CHILDHOOD *by Annie Dillard*

Brookline, Massachusetts

*T*he dusk had deepened, and the humidity thickened into a palpable, prickly drizzle that lent my walk a heightened feeling of sheltered stealth. I knew *this* side of the street from the dawn of my consciousness: our neighbors the Matzes and the Pritchards, and Hen Kieffer's grocery store, and the Krings' and the Pottses' houses, where my first playmates, all girls, lived. These houses down the street, though not every inhabitant was known by name to me, had each been as distinct to my childish awareness as the little troughs in the cement which led rain from their roof gutters out through the sidewalk to the street, and which punctuated my progress on roller skates or on my scooter . . . These houses, on the "safe," on "our," side of the street, however little or much I knew them from the inside, knew me—Wes and Linda Updike's boy, John and Katie Hoyer's grandson. Where now I made my way down the pavement on Proust's dizzying stilts of time, virtually floating, a phantom who had not set foot on these very squares of cement for perhaps thirty years, I had once hastened low to the ground, day after day, secure as a mole in the belief that I was known, watched, placed.

—*from*
SELF-CONSCIOUSNESS
by John Updike

Plano, Texas

I come from people who believe the *home place* is as vital and necessary as the beating of your own heart. It is that single house where you were born, where you lived out your childhood, where you grew into young manhood. It is your anchor in the world, that place, along with the memory of your kinsmen at the long supper table every night and the knowledge that it would always exist, if nowhere but in memory.

Such a place is probably important to everybody everywhere, but in Bacon County—although nobody to my knowledge ever said it—the people understand that if you do not have a home place, very little will ever be yours, really *belong* to you in the world. Ever

Near Colorado City, Colorado, circa 1920

since I reached manhood, I have looked back upon that time when I was a boy and thought how marvelous beyond saying it must be to spend the first ten or fifteen years of your life in the same house—the *home* place—moving among the same furniture, seeing on the familiar walls the same pictures of blood kin. And more

marvelous still, to be able to return to that place of your childhood and see it through the eyes of a man, with everything you see set against that long-ago, little boy's memory of how things used to be.

—*from* A CHILDHOOD: THE BIOGRAPHY OF A PLACE *by Harry Crews*

For Tar Moorehead life began with a procession of houses. They were at first very dim in his mind. They marched. Even when he grew to be a man the houses went across the walls of his fancy like soldiers in a dusty road. As when soldiers marched some few were sharply remembered.

Houses were like people. An empty house was like an empty man or woman. They were houses cheaply built, thrown together. Others were carefully built and carefully lived in, having careful loving attention.

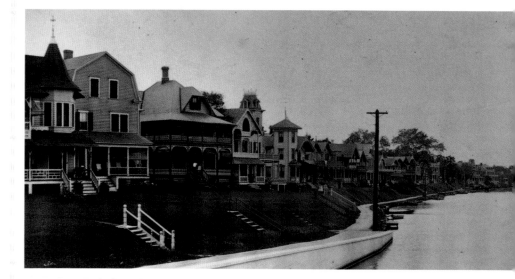

Ocean Grove, New Jersey, 1937

When you went into an empty house the experience was sometimes terrifying. Voices kept calling. They must have been the voices of people who had lived there . . . To a mind like Tar's — the truth always washed by the colors being brushed on by his fancy — houses in which he lived as a child could not be definitely placed. There was one house [he was quite sure] he had never lived in that was very clearly remembered. The house was low and long and a grocer with a large family lived in it . . . Tar's own family must have lived near this house and no doubt he wanted to live under its roof. A child is always wanting to try the experiment of living in some house other than his own.

—*from* TAR: A MIDWEST CHILDHOOD *by Sherwood Anderson*

I would take any refuge from the thorough-fare of plain living—the doll-house, the tree-house, the hidden room under the stairs, the closet, tunnels through furniture, the tablecloth tent, the attic, the bower in the cedar tree. I would take any platform or den that got me above, under, or around the corner from the everyday. There I pledged allegiance to what I knew, as opposed to what was common. My parents' house itself was a privacy from the street, from the nation, from the rain. But I did not make that house, or find it, or earn it with my own money. It was given to me. My separate hearth had to be invented by me, kindled, sustained, and held secret by my own soul as a rehearsal for departure.

—*from* "THE SEPARATE HEARTH" *by Kim R. Stafford*

Quincy, Massachusetts

Of the uncounted places I have lived in, for years or months, only one haunts me. Since I left it for good, I have been adrift, and shall drift to my death. Yet I cannot go back there—any more than a tree, cut down, could return to its roots left in the ground . . .

There is a sense in which it is true that we only live in one house, one street, one town, all our lives. I have no memory of the first house I lived in, though I ought to be able to remember an afternoon in my sixth month when I began climbing its dangerously steep staircase on hands and knees: I set off six times, and was fetched back and whipped six times.

Have I been doing anything ever since except setting off again up those infernal stairs?

—*from* JOURNEY FROM THE NORTH *by Storm Jameson*

*H*ome, in one form
or another, is the
great object of life.

—*from* GOLD FOIL: HOME
by Josiah G. Holland

*T*o be happy at home
is the ultimate
result of all ambition, the
end to which every enter-
prise and labor tends . . .

—*Samuel Johnson*

15

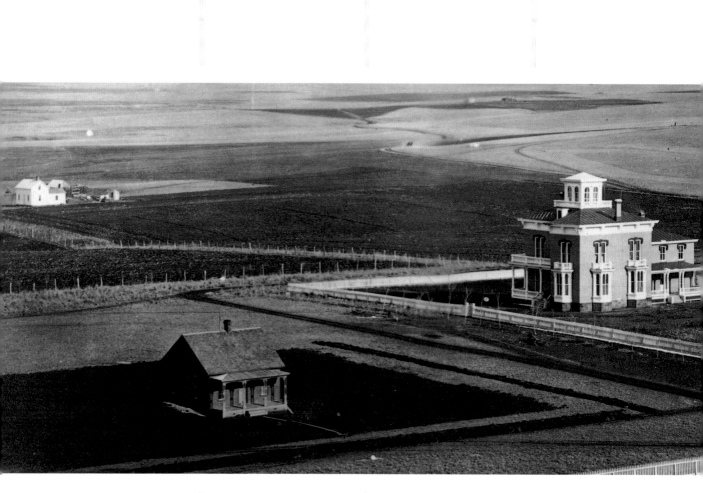

Lincoln, Nebraska, 1869

To take possession of space is the first gesture of the living, man and beasts, plants and clouds, the fundamental manifestation of equilibrium and permanence. The first proof of existence is to occupy space.

—*Le Corbusier*

For centuries a home was not merely shelter but the place where the sense of family was preserved ... It was the mausoleum where family memorabilia created a history. It was the structure, along with the land around it, that transmitted a family's wealth through generations ... The home has lost much of its mythic destiny, because people no longer have one home but different homes of different types at different times of their lives.

—*from* "WHY THE HOME-AS-CASTLE ISN'T WHAT IT USED TO BE," *an interview with Ettore Sottsass by Robert Suro*

Sturgeon Bay, Wisconsin, New Year's Day, 1900

New Hope, Pennsylvania

*W*here shall a man find sweetness to surpass

his own home and parents? In far lands

he shall not, though he find a house of gold.

—*from* THE ODYSSEY *by Homer*

*I*ntreat me not to leave thee, or to return from following after thee: for whither thou goest, I will go; and where thou lodgest, I will lodge: thy people shall be my people, and thy God my God.

—*from* THE BOOK OF RUTH

*W*here Thou art—that is Home.

—*Emily Dickinson*

*W*ithout hearts there is no home.

—*George Gordon Byron (Lord Byron)*

*H*ome is where the heart is.

—*Pliny the Elder*

Lincoln, Nebraska, 1952

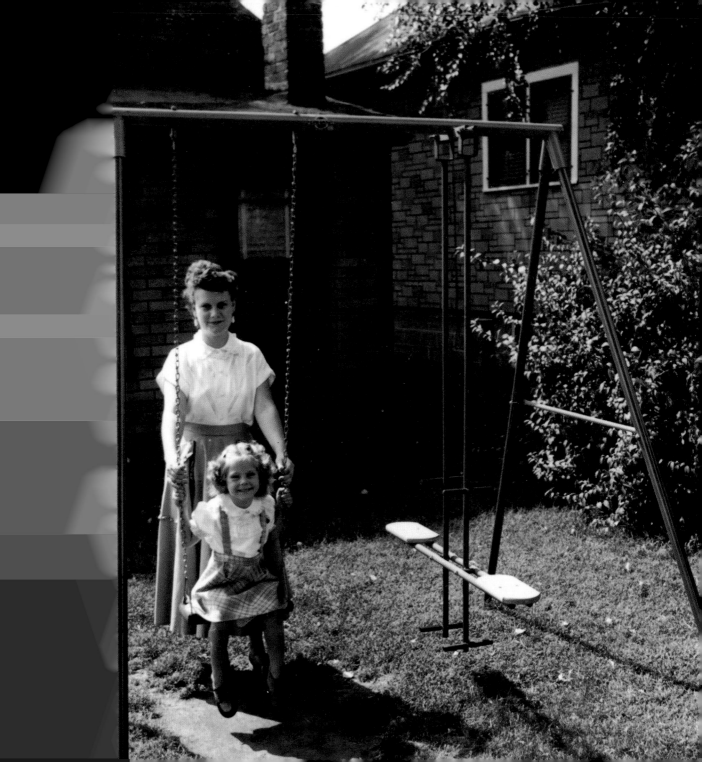

Nomads. We are all nomads & all chimney ornaments by turns, & pretty rapid turns. I fancy the chief difference that gives one man the name of a rover & one of a fixture, is the faculty of rapid domestication, the power to find his chair & bed everywhere, which one man has & another has not. In Paris, a man needs not to go home ever. He can find in any part of the city his coffee, his dinner, his newspaper, his company,

Near Laramie, Wyoming,
circa 1897

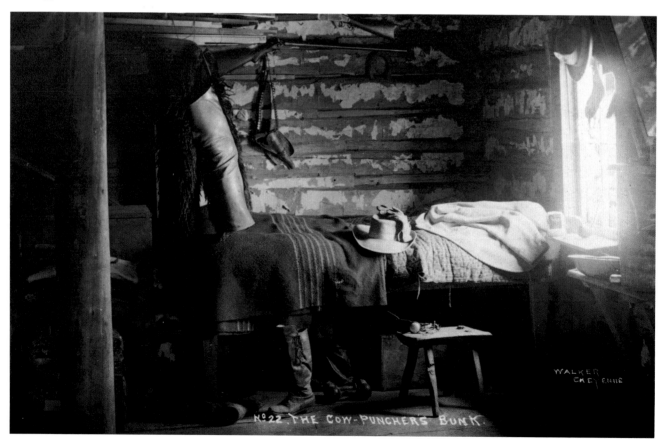

N°22. THE COW-PUNCHER'S BUNK.

WALKER
CHEYENNE

his theatre, & his bed, as good as those he left. And some men have constitutionally such habits of accommodation, that, at sea, or in the forest, or in the snow, they sleep as warm & dine with as good appetite, & associate as well as in the house where they were born.

—*from* THE JOURNALS AND MISCELLANEOUS NOTE-BOOKS OF RALPH WALDO EMERSON *by Ralph Waldo Emerson*

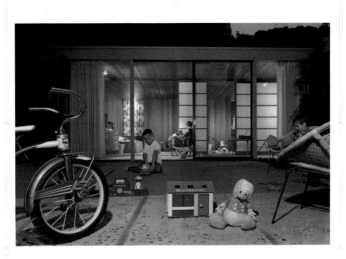

Los Angeles, California, 1959

I suggest we think about places in the context of two reciprocal movements which can be observed among most living forms: like breathing in and out, most life forms need a *home* and *horizons of reach* outward from that home. The lived reciprocity of rest and movement, of territory and range, of security and adventure, of housekeeping and husbandry, of community building and social organization— these experiences may be universal among the inhabitants of Planet Earth.

—*from* "HOME, REACH AND SENSE OF PLACE" *by Anne Buttimer*

21

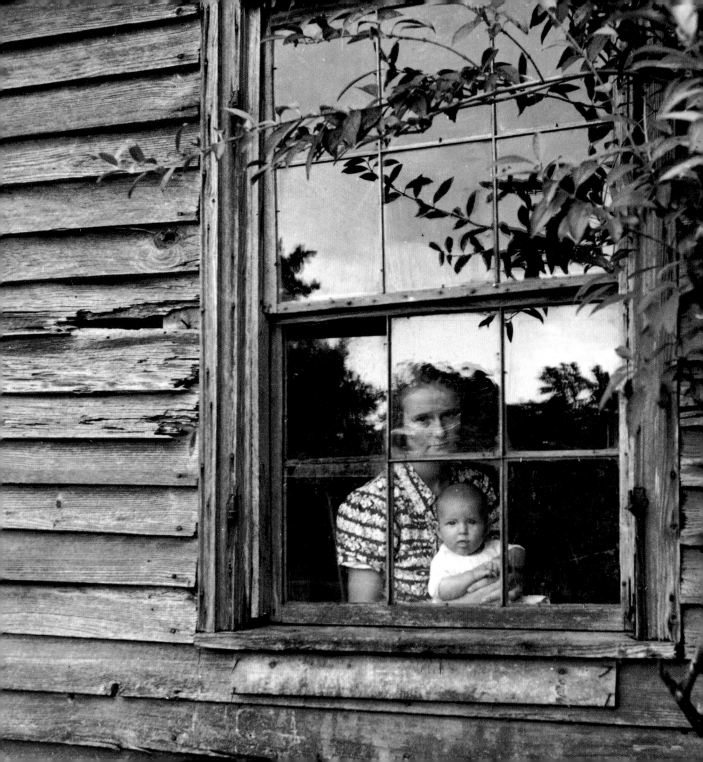

*T*he feeling of being "at home" is the feeling of belonging, a sense of the fitness of "having come down where we want to be," as the Shaker song puts it. It springs from the reassuring sound of movement in another room, from familiar odors that rise in welcome, from the feel of still-warm blankets on a bed. It is the history that clings to remembered objects, those small moments of delight when a childhood memory is dislodged by a chance encounter with the past.

No one who has ever been homesick as a child can forget the almost physical pain that held him like the talons of a giant bird of prey. Our attachment to the familiar can be transferred so that the person who has once been claimed and connected can bring her imaginative sense of place with her and feel at home anywhere; but to the words "I just don't feel at home here," there is no reply and no remedy. Home is the psychic destination of all our travels.

—*from* NO PLACE LIKE HOME *by Linda Weltner*

Granville County, North Carolina, 1939

Minneapolis, Minnesota, 1905

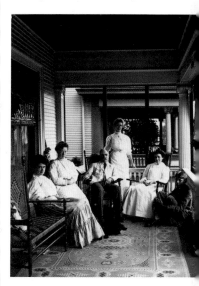

*H*ome is the place where, when you have to go there, they have to take you in.

—*from* "THE DEATH OF THE HIRED MAN" *by Robert Frost*

23

Sarah Orne Jewett and Emily Tyson, South Berwick, Maine, 1905

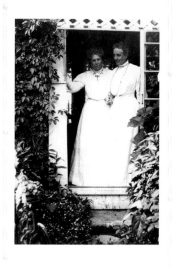

*I*was born here and I hope to die here, leaving the lilac bushes still green and growing, and all the chairs in their places . . .

—*Sarah Orne Jewett*

*I*n home-sickness you must keep moving —it is the only disease that does not require rest.

—*H. de Vere Stacpoole*

San Juan Bautista, California

24

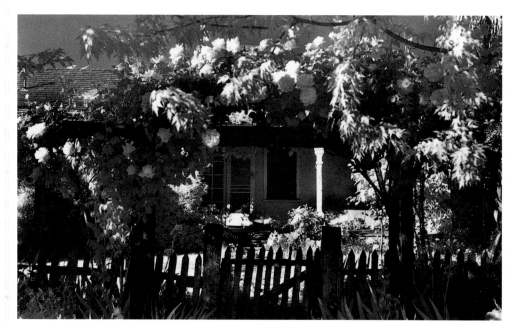

*T*hink of the consummate folly of attempting to go away from *here*! When the constant endeavor should be to get nearer and nearer *here* . . . How many things can you go away from? They see the comet from the northwest coast just as plainly as we do, and the same stars through its tail. Take the shortest way round and stay at home . . . *Here*, of course, is all that you love, all that you expect, all that you are . . . Foolish people imagine that what they imagine is somewhere else.

—*from* THE JOURNALS OF HENRY DAVID THOREAU *by Henry David Thoreau*

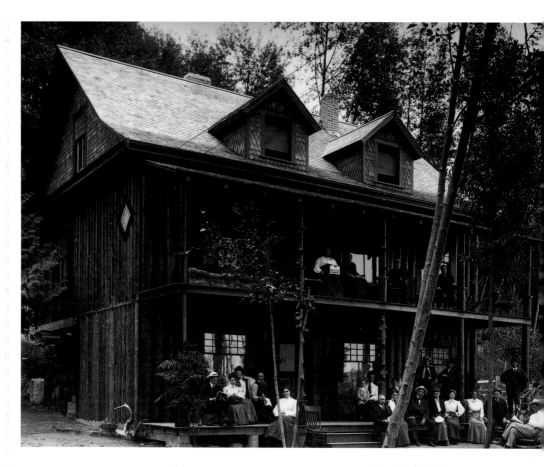

Near Seattle, Washington, 1910

25

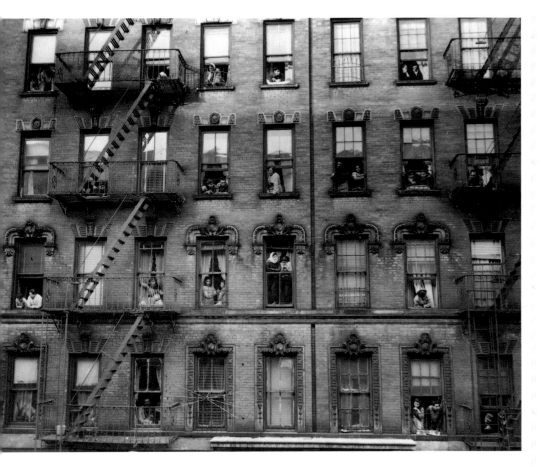

New York, New York,
circa 1955

*N*eighbor in its root
meaning in the
Germanic languages is a
"nigh (near) dweller."
What is expressed is a
"spatial relationship" in
which, evidently, the scale
is open, dependent on the
patterns of settlement
and circulation. But *near*
here also implies closeness
in a social sense, with the
existence of some mutu-
ality of obligation, trust,
affection; conversely, these
decay with distance.

—*from* "THE STRUCTURING
OF SPACE IN PLACE NAMES
AND WORDS FOR PLACE"
by David E. Sopher

*T*he Dutch loved their homes. They shared this old Anglo-Saxon word—*ham, hejm* in Dutch—with the other peoples of northern Europe. "Home" brought together the meanings of house and of household, of dwelling and of refuge, of ownership and of affection. "Home" meant the house, but also everything that was in it and around it, as well as the people, and the sense of satisfaction and contentment that all these conveyed. You could walk out of the house, but you always returned home.

—*from* HOME: A SHORT HISTORY OF AN IDEA *by Witold Rybczynski*

*T*he earliest animal to come under domestication was man; and the very word we use to describe the process reveals its point of origin. For 'domus' means home; and the first step in domestication, which made all the later ones possible, was the establishment of a fixed hearth with a durable shelter: possibly in the midst of a forest clearing, where the first cultivated plants could be watched by the womenfolk, while the men continued to range abroad in search of game or fish.

—*from* THE MYTH OF THE MACHINE: TECHNICS AND HUMAN DEVELOPMENT *by Lewis Mumford*

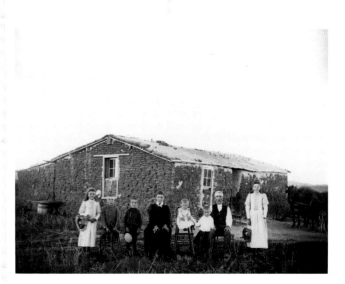

Southwest Custer County, Nebraska, 1892

27

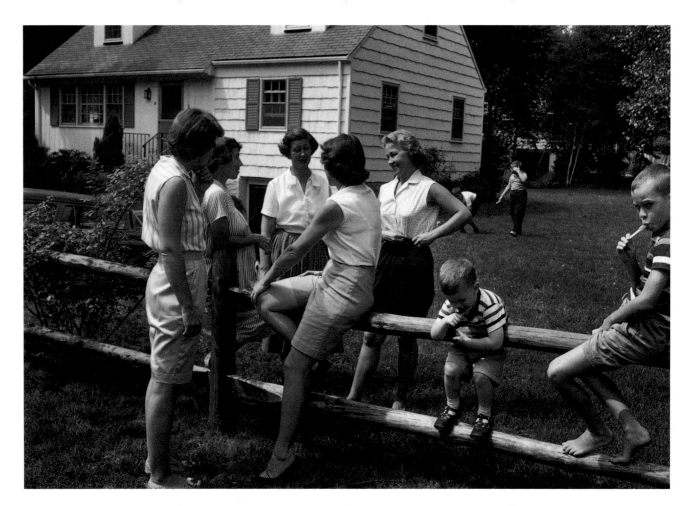

White Plains, New York,
circa 1960

28

*T*o be rooted is per- haps the most important and least recognized need of the human soul. It is one of the hardest to define. A human being has roots by virtue of his real, active, and natural participation in the life of a community, which preserves in living shape certain particular treasures of the past and certain particular expectations for the future: The participation is a natural one, in the sense that it is automatically brought about by place, conditions of birth, profession, and social surroundings. Every human being needs to have multiple roots.

—*from* THE NEED FOR ROOTS *by Simone Weil*

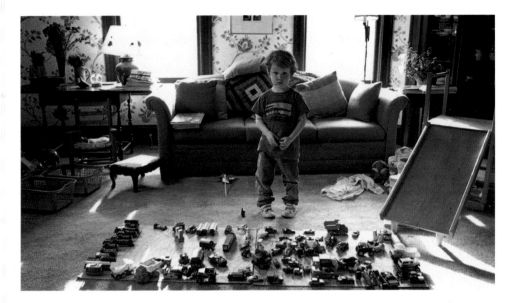

Carlisle, Massachusetts

*H*ome is where you keep your stuff while you're out getting other stuff.

—*George Carlin*

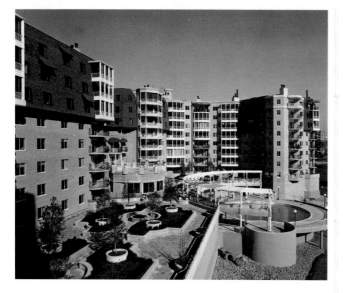

Washington, D.C.

*O*ur convictions about the home go down to the uttermost depths, and have changed less under the tooth of time than any others, yet the facts involved have altered most radically. The structure of the home has changed from cave to tent, from tent to hut, from hut to house, from house to block or towering pile of "flats"; the inmates of the home have changed, from the polygamous group and its crowd of slaves, to the one basic family relation of father, mother, and child; but our feelings have remained the same.

—*from* THE HOME *by Charlotte Perkins Gilman*

*I*n 1678 the word 'nostalgia' was coined by a Swiss medical student, Johannes Hofer, to describe an illness that was characterised by such symptoms as insomnia, anorexia, palpitations, stupor, fever, and especially persistent thinking of home . . . Although we might now use the term 'homesickness' as a synonym for nostalgia, it is a weak synonym, for Hofer and subsequent physicians of the seventeenth and eighteenth centuries believed that this was a disease that could result in death if the patient could not be returned home. Nostalgia demonstrates that the importance of attachment to place was once well-recognised.

—*from* PLACE AND PLACE-LESSNESS *by E. Relph*

A house is the only regularly occurring symbol of the whole human body in dreams.

—*Sigmund Freud*

30

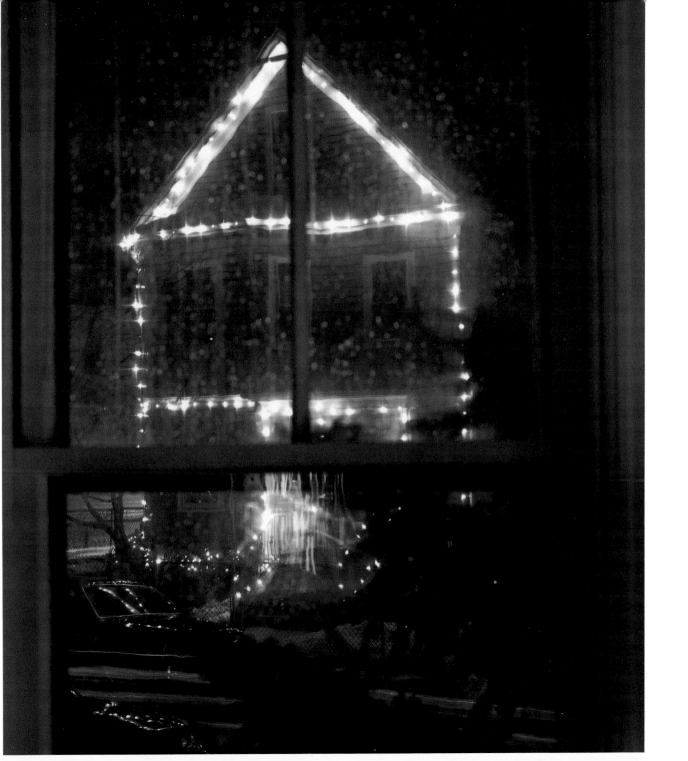

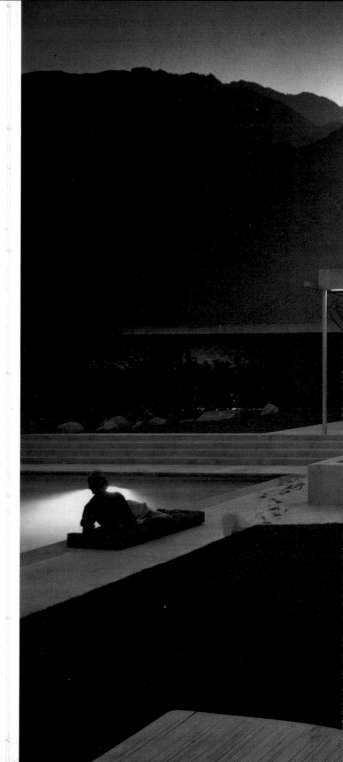

"*The joining of person to place, as of person to person, is a commitment to shared sorrow, even as to shared joy . . .*"

Palm Springs, California, 1947

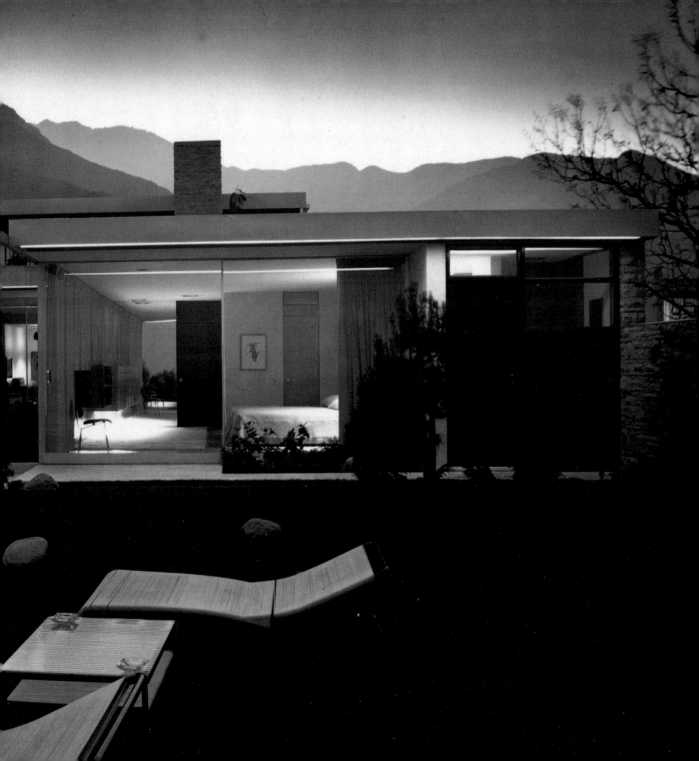

The home of Marjorie Kinnan Rawlings at Cross Creek, Florida

When I came to the Creek, and knew the old grove and farmhouse at once as home, there was some terror, such as one feels in the first recognition of a human love, for the joining of person to place, as of person to person, is a commitment to shared sorrow, even as to shared joy.

—*from* CROSS CREEK *by Marjorie Kinnan Rawlings*

I paused, on the evening of my arrival, before my future home. I said to myself, here I shall live for one, two, three, possibly four years; how familiar will be that unfamiliar gate; I arrive with curiosity, I shall leave, I hope, with regret. And I foresaw myself leaving, and my eyes travelling yearningly over the house and the little garden, which in a moment the bend of the lane would hide from me forever. I say forever, for I would not court the disillusion of returning to a once happy home.

Then, as my eyes began to sting with prophetic sorrow of departure, I remembered that my one, two, three, or possibly four years were before and not behind me; so, amused at my own sensibility, I pushed open the swing-gate and went in.

—*from* HERITAGE *by Vita Sackville-West*

The sitting room at Cross Creek

Faribault, Minnesota, 1941

35

Harwichport, Massachusetts

We have builded us a little house on the sea-cliff here; it is just a year since we came to live in it. A delightful place we think, cormorants on the sea-rocks in front of us, and pelicans drifting over-head; it is a promontory, with water on three sides of us. The house and garage walls are gray granite — sea-boulders, like the natural outcrop of the hill. In foolish frankness, it is the most beautiful place I have ever seen.

—from a letter (1920) by Robinson Jeffers

America is the most "house proud" of nations. The single-family house is the most visible image of our wealth and liberty. The typical American house, no matter how modest, reveals in its architectural conventions subliminal expressions of the themes — the myths, even — of our history, our traditions, and our dreams: lapped siding, for example, denotes a farm-house, while natural shin-gles conjure up houses confronting a storm-tossed sea. Red tile roofs and porches suggest the haciendas of the Southwest, where Spaniard and Indian forged a socially uneasy but physically beguiling

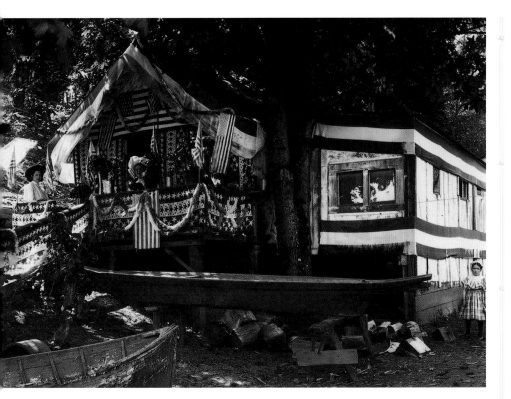

Seattle, Washington, 1905

architectural synthesis. Every detail of the American single-family house—the American dream house—from the handling of the bricks or stone or stucco to the hurricane lamps in the picture windows and the decorative wagon wheel on the front lawn, defines who we are in terms of our need to appropriate the past, raise it to mythic proportions, and make it our own.

—*from* PRIDE OF PLACE *by Robert A. M. Stern*

Seattle, Washington, 1905

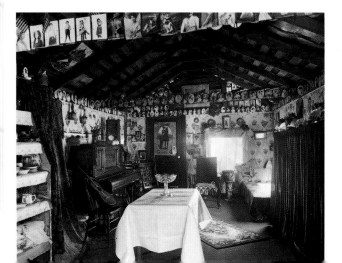

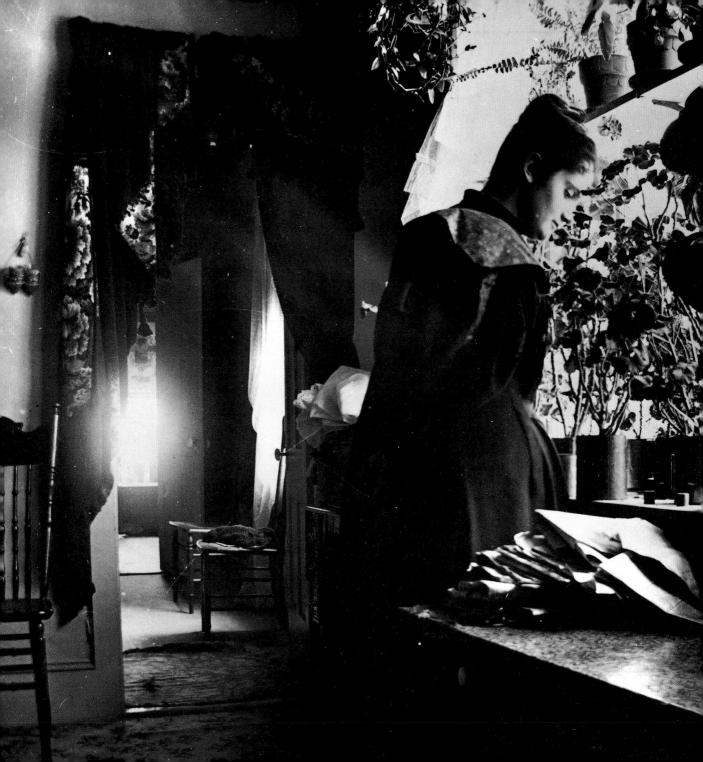

Dear Mother,
Well, I am writing this from my big "back kitchen" (not really a kitchen, for I cook and wash up in a small room across the hall) . . . surrounded by my copper saucepans and the Dutch tea set you brought, all displayed in the various lovely nooks and crannies. A large coal stove warms this room and keeps all the water piping hot (although we can switch on hot water independently of it in the electric immersion heater upstairs); and, at last, I have all the room I could wish for and a perfect place for everything . . .

The place is like a person; it responds to the slightest touch and looks wonderful immediately. I have a nice, round dining table we are "storing" for the couple who have moved into our London flat, and we eat on this in the big back room, which has light-green linoleum on the floor, cream wood paneling to shoulder height, and the pink-washed walls that go throughout the house . . . There's lots of space for Frieda to run about and play and spill things here—really the heart-room of the house, with the toasty coal stove Ted keeps burning.

. . . My whole spirit has expanded immensely—I don't have that crowded, harassed feeling I've had in all the small places I've lived in before. Frieda adores it here. The house has only one shallow step to get down from the back court into the back hall and another shallow step into the front garden, so she can run in and out easily with no danger of falls, and she loves trampling through the big rooms . . .

What is so heavenly here is the utter peace.

—*from a letter to her mother (1961) by Sylvia Plath*

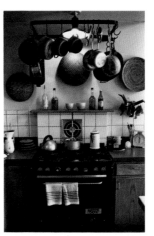

*T*he very commonplaceness of this old farmhouse, the ordinariness of its site and its views, are all just what they should be, our life being what it is. This is not some magnificence I dreamed of, plotted for, and finally achieved; but a place I came upon as one may come upon an inn when the day is over and the hour to stop for the night has come. Whatever comeliness our home may have is what we have given the house and the land out of sheer neighborly intimacy.

—*from* MY WORKS AND DAYS *by Lewis Mumford*

I don't care anything about his house," said Isabel.

"That's very crude of you. When you've lived as long as I you'll see that every human being has his shell and that you must take the shell into account. By the shell I mean the whole envelope of circumstances. There's no such thing as an isolated man or woman; we're each of us made up of some cluster of appurtenances. What shall we call our 'self?' Where does it begin? where does it end? It overflows into everything that belongs to us—and then it flows back again. I know a large part of myself is in the clothes I choose to wear. I've a great respect for *things*! One's self—for other people—is one's expression of one's self; and one's house, one's furniture, one's garments, the books one reads, the company one keeps— these things are all expressive."

—*from* THE PORTRAIT OF A LADY *by Henry James*

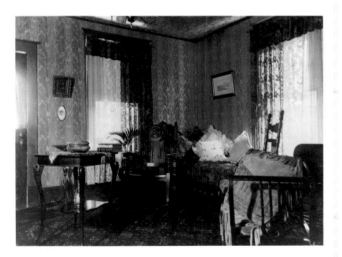

Lincoln, Nebraska, 1904

*S*he walked quickly around her one-room apartment, with a sureness that came of habit rather than conviction; after more than four years in this one home she knew all its possibilities, how it could put on a sham appearance of warmth and welcome when she needed a place to hide in, how it stood over her in the night when she woke suddenly, how it could relax itself into a disagreeable unmade, badly-put-together state, mornings like this, anxious to drive her out and go back to sleep.

—*from* "ELIZABETH" *by Shirley Jackson*

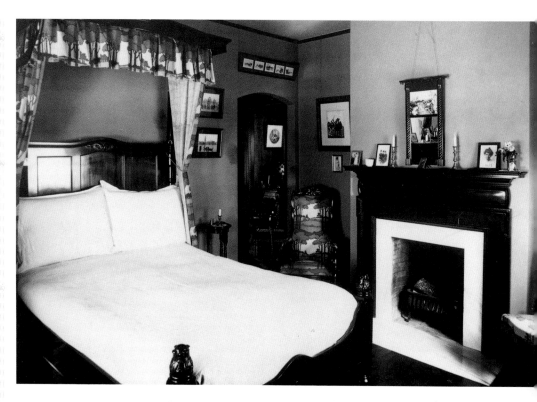

St. Paul, Minnesota, circa 1903

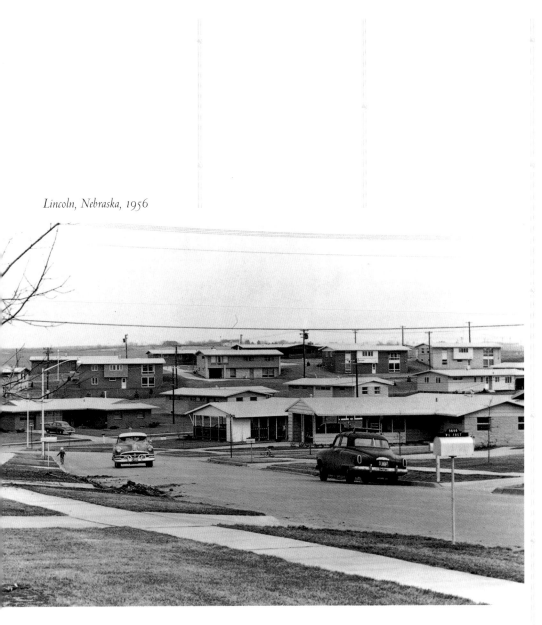

Lincoln, Nebraska, 1956

You can see this freestanding, privately owned, single-family house everywhere you go—in the small towns of Ohio and California and Kansas, in big cities like Chicago, Houston, and Atlanta, in suburbs all across the country. It is set back from the street; it has a frontyard with a lawn and a tree or two, a garage or carport, and a backyard for barbecuing. The lawn extends from house to house, uninterrupted by fences; there are miles of bluegrass front lawns in midwestern towns and suburbs, stretching on both sides of the street for blocks on end. The backyard is more private. It usually is fenced in, and might have a picnic table, a toolshed, a barbecue pit. Whatever the

HERALD-POST MODEL HOME

WEBB-CLARK CO.
BUILDERS

BLAND ELECTRIC CO.
Electric Wiring

C.W. BRICKLEY LUMBER CO.
Fenestra Steel Casements

A.S. BLUNK HEATING CO.
Heating

GEO. G. ADAMS
High Grade Screens

C.W. BRICKLEY LUMBER CO.
Kitchen Maid Cabinets

R.C. TWAY COAL CO.
Lehigh Cement & Miles Tile

KY. LUMBER & MILLWORK CO.
Lumber & Millwork

FRANK HARTMAN & SONS
Painting & Decorating

W.E. GORE
ARCHITECT

HUBBUCH BROS. & WELLENDORF
Wall Papering

BLACKBURN & DAVIS
Crane Plumbing

AMERICAN BUILDERS SUPPLY CO.
Richardson Multicrome Roof

J.F. WAGNERS & SONS
Sheet Metal

The PYNE CO.
Structural Steel

SERVEL - *The perfect refrigerator*
Gas & Electric Shop

HEGAN-MAGRUDER CO.
Tile Work

PORTLAND ELECTRIC CO
Riddle Fittments

DE GRAW PROPERTIES CORPORATION

WM. J. RUEFF

Louisville, Kentucky, circa 1920

external trim, inside, the houses are not very different from one another. Each has two or more bedrooms, at least one and a half bathrooms, a family room with the main television set, and a kitchen equipped with dishwasher, electric range, and refrigerator.

Today we take this house for granted; for us it is as common as the ubiquitous skyscraper, fast-food outlet, or department store. To those raised in other cultures, however, the average American house must seem an extravagant domestic setting, in its spaciousness, the specialized uses of its several rooms, the mechanical systems, and labor-saving devices. Even to European visitors, the American house is distinctive, and peculiar in a number of ways. To begin with, the free-standing house itself is a rarity in Europe. Europeans are by and large dwellers of apartments and rowhouses. And for an intended occupancy of one family, two to six people, American houses are very big—enormous, in fact, by European standards.

—*from* AMERICA BY DESIGN *by Spiro Kostof*

*D*ine on onions, but have a home; reduce your food and add to your dwelling.

—THE TALMUD

43

*Near Denver, Colorado,
circa 1930*

*A*man is not whole
and complete
unless he owns a house
and the ground it
stands on.

—*Walt Whitman*

*F*unny thing how it
is. If a man owns a
little property, that property is him, it's part of
him, and it's like him. If
he owns property only so
he can walk on it and
handle it and be sad when
it isn't doing well, and feel
fine when the rain falls on
it, that property is him,
and some way he's bigger
because he owns it. Even
if he isn't successful he's
big with his property.
That is so."

—*from* THE GRAPES OF
WRATH *by John Steinbeck*

Louisville, Kentucky, 1931

*T*o possess one's own home is the hope and ambition of almost every individual in our country, whether he lives in a hotel, apartment, or tenement . . . Those immortal ballads, "Home Sweet Home," "My Old Kentucky Home," and "The Little Gray Home in the West," were not written about tenements or apartments. . . . They never sing songs about a pile of rent receipts.

—*Herbert Hoover*

A nation of home-owners, of people who won a real share in their own land, is unconquerable.

—*Franklin D. Roosevelt*

Perhaps no one ever really owns a house at all. Strong-minded houses, like certain old women with real character, if they survive at all, stubbornly remain uncorrupted. Cosmetics and the latest fashions don't affect them. "One says 'my house, my home'" wrote Doris Lessing. "Nonsense. People flow through houses, which stay the same, adapting themselves only slightly for their occupants."

—*from* THE FALL OF A DOLL'S HOUSE *by Jane Davison*

Lincoln, Nebraska, 1950

My husband and I were shown this property, and bought it in May 1978, in a single fevered afternoon, the way we seem to make most of the crucial decisions of our lives . . . In human relations, love at first sight is usually a mistake. In house buying, it is usually the only reliable guide. So we bought the house and moved into it. And when visitors say, as they sometimes do, "Your house is just like you," I take it as a compliment instead of

Ojai, California, 1952

dwelling on what they might mean in terms of secrecy or exposure (All that glass! So many doors!), let alone deception . . .

—*from* "PRINCETON PASTORAL" *by Joyce Carol Oates*

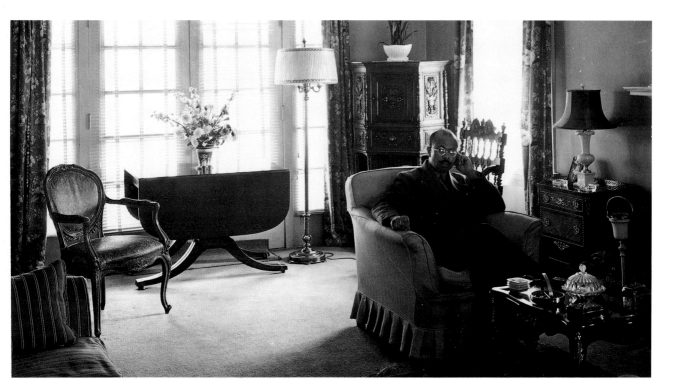

Chicago, Illinois, 1941

*M*y house was a canvas on which other people had been painting (or, more recently, wallpapering) for more than two hundred years. . . . Every house is a work in progress. It begins in the imaginations of the people who build it and is gradually transformed, for better and for worse, by the people who occupy it down through the years, decades, centuries. To tinker with a house is to commune with the people who have lived in it before and to leave messages for those who will live in it later.

Every house is a living museum of habitation, and a monument to all the lives and aspirations that have flickered within it.

—*from* THE WALLS AROUND US *by David Owen*

Lincoln, Nebraska, 1951

uying a house was a grave error; it doesn't come with a land-lord or a super or a handyman, people to blame. To my friends, it may look like autumn leaves. To me, it is a rainbow of debt."

He had bought the house to declare his adulthood. His family would no longer be transients, refugees. Mortgages were a form of seriousness. Having sought to expand his protection, had he merely multiplied occasions for incompetence? His children supposed him capable of heroism. What if they found out he couldn't shut a valve . . .

—*from* PRIVATE LIVES IN THE IMPERIAL CITY *by John Leonard*

The Age of Property holds bitter moments even for a proprietor. When a move is imminent, furniture becomes ridiculous, and Margaret now lay awake at nights wondering where, where on earth they and all their belongings would be deposited in September next. Chairs, tables, pictures, books, that had rumbled down to them through the generations, must rumble forward again like a slide of rubbish to which she longed to give the final push, and send toppling into the sea. But there were all their father's books—they never read them, but they were their father's, and must be kept. There was the marble-topped cheffonier—their mother had set store by it, they could not remember why. Round every knob and cushion in the house sentiment gathered, a sentiment that was at times personal, but more often a faint piety to the dead, a prolongation of rites that might have ended at the grave.

It was absurd, if you came to think of it; Helen and Tibby came to think of it: Margaret was too busy with the house-agents. The feudal ownership of land did bring dignity, whereas the modern ownership of movables is reducing us again to a nomadic horde. We are reverting to the civilization of luggage, and historians of the future will note how the middle classes accreted possessions without taking root in the earth, and may find in this the secret of their imaginative poverty. The Schlegels were certainly the poorer for the loss of Wickham Place. It had helped to balance their lives, and almost to counsel them.

—*from* HOWARDS END *by* E. M. Forster

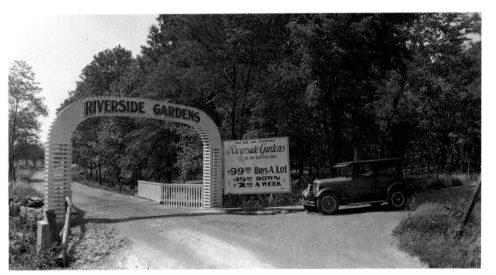

Louisville, Kentucky, circa 1925

We did not own a home. My parents, fresh from off the farm, were new to Clarksville. We could not afford to own a home, we rented; and we were continually moving. Houses for rent stood vacant in those depression years, and a vacant house could not be insured. Landlords waged a price war to attract tenants; as times worsened, they let them rent-free to families known to take good care of them. My mother had quickly earned herself a name around town as a good housekeeper—"I believe in leaving a place cleaner than I found it," she said, ending, as she always did, "just like my mother taught me"—

and she had her pick of houses. Indeed, she was in demand, wooed by landlords, who came around often to make sure that everything was to her liking, and who begged her to say what was wrong, why she was leaving, whenever she announced that we were moving, even when we were paying no rent. She would leave a house because she had seen a mouse. My mother was a restless one, never happier than on moving day—such a chore for most women—even when we were moving back now to a house we

had lived in before, and which, at the time, she could not get out of fast enough. She sang and whistled as she packed the tubs and crates, her hair wrapped in a rag. I was like her; I liked moving often, too. I liked change. I liked exploring new neighborhoods. In each I got to know better those of my schoolmates who lived there; meanwhile, I was not really saying goodbye to those I was leaving behind. We must have lived in fifteen different houses scattered around town in the course of some five years. One day I came home from school and took a glass of milk and a banana from the icebox,

only to have a strange lady—that is to say, a lady I knew, but who was not my mother—come in and say, "Billy? Is that you? But you don't live here any more, hon'. Did you forget? You all moved out today and we moved in here. You live out on Third Street now."

—*from* FARTHER OFF FROM HEAVEN *by William Humphrey*

*T*heir life, collapsed
like unplayed cards,

is carried piecemeal
through the snow:

Headboard and
footboard now, the bed

where she has lain
desiring him

where overhead his sleep
will build

its canopy to smother her
once more;

their table, by four elbows
worn

evening after evening
while the wax runs down;

mirrors grey with
reflecting them,

bureaus coffining from
the cold

things that can shuffle in
a drawer,

carpets rolled up around
those echoes

which, shaken out, take
wing and breed

new altercations, the old
silences.

—"MOVING IN WINTER"
by Adrienne Rich

Jigsaw puzzle, Quincy,
Massachusetts

I cannot tell you how we moved. I had rather not remember. I believe my "effects" were brought in a bandbox, and the "deathless me," on foot, not many moments after. I took at the time a memorandum of my several senses, and also of my hat and coat, and my best shoes — but it was lost in the *mêlée*, and I am out with lanterns, looking for myself.

Such wits as I reserved, are so badly shattered that repair is useless — and still I can't help laughing at my own catastrophe. I supposed we were going to make a "transit," as heavenly bodies did — but we came budget by budget, as our fellows do, till we fulfilled the pantomime contained in the word "moved." It is a kind of *gone-to-Kansas* feeling, and if I sat in a long wagon, with my family tied behind, I should suppose without doubt I was a party of emigrants!

They say that "home is where the heart is." I think it is where the *house* is, and the adjacent buildings.

—from a letter (1856) by Emily Dickinson

The home of Emily Dickinson, Amherst, Massachusetts

52

Twin Falls, Idaho, 1908

*A*man builds a house in England with the expectation of living in it and leaving it to his children; while we shed our houses in America as easily as a snail does his shell.

—*Harriet Beecher Stowe*

*W*hen a house has yielded all its essence, simple prudence counsels us to abandon it. It's a rind, a shell. We risk becoming its flesh, its kernel, of being consumed even unto death. Better to depart, to take the chance of at last finding a shelter that one can't exhaust; any peril is less than that of remaining . . .

I have friends who pass as mentally normal, except that the idea of moving makes them screw up their eyes, shrug their shoulders, and put their hands over their ears . . . The bibliophiles suffer more in advance than others at the thought of moving. The collector of rare china suffers less because he knows—even should the house collapse, or the floor above accommodate a dancing school and an academy of singing—he knows that he will die rather than move.

—*from* PLACES *by Colette*

53

"We shape our dwellings, and then . . ."

Hardy's Furniture Store, Lincoln, Nebraska, circa 1927

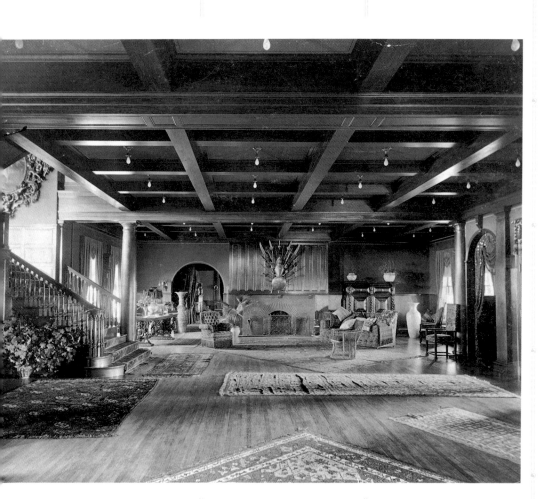

*W*e shape our dwellings, and then our dwellings shape us.

——*Winston Churchill*

Minneapolis, Minnesota, circa 1905

56

Washington, D.C.

\mathcal{T}he front door has always been a place of great symbolic importance. Ever since men lived in caves, the front door—and its threshold—have demarcated the transition between the inside and outside, between safety and danger, between the public and the private worlds. We angrily show people the door, or considerately we walk them to it; we knock on the door and wait to be invited in. It is the place for many everyday ceremonies of arrival and departure, for familial hugs and for furtive, adolescent goodnight kisses. It is the memory of these that gives front doors personality—that is why we adorn them with Christmas wreaths and Thanksgiving corn.

The importance of a clearly visible front door, then, is only incidentally to orient the visitor; that, as Eco would say, is its primary sign-function. Its secondary purpose, which has become predominant, is connotative and symbolic: it celebrates arrival and departure; it is a sign of welcome as well as an acknowledgment of the vulnerable breach in the inviolable boundary of the domestic sphere. It signals "home."

—*from* THE MOST BEAUTI-FUL HOUSE IN THE WORLD *by Witold Rybczynski*

Santa Fe, New Mexico, 1965

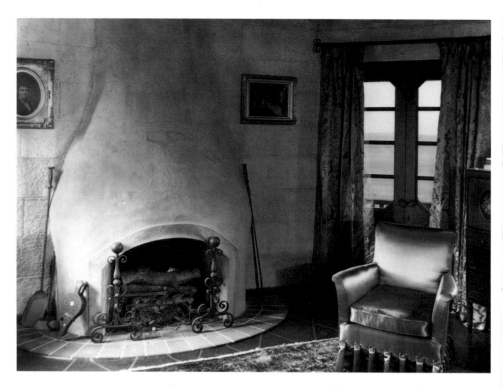

*I*t is pleasant, when you have been out, to feel the hominess of your house as soon as you open the front door. It is a kind of daily house welcome, a kind of everyday "open sesame." It is for that reason that our log fireplace was put opposite the front door. Our fireplace has a shelf above it with Bruges pottery and Munich brasses and some copper

Del Mar, California

Santa Fe, New Mexico

plates we made ourselves. We love these things, but above all we love the logs. The log fire is the poetry of home. No matter how much we appreciate the prose of our hot water furnace in the cellar, in the development of mankind poetry came before prose and the hearth is the poetic symbol of home. It is this poetry of home which is its perennial charm, and in this large poetry of home the poetry of our household possessions has a deep rooted spot.

—*from* "OUR HOME-BUILDING" *by Antoinette Rehmann*

Woodstock, New York

New York, New York

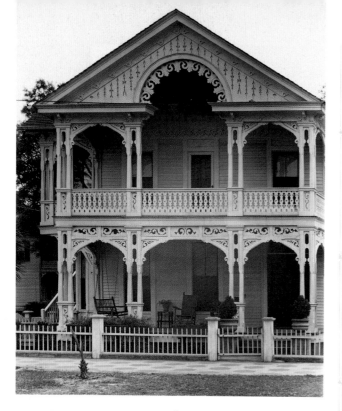

Fernandez, Florida, 1936

Of porches there are two sorts: the decorative and the useful, the porch that is only a platform and the porch you can lie around on in your pajamas and read the Sunday paper.

The decorative porch has a slight function, similar to that of the White House portico: it's where you greet prime ministers, premiers, and foreign potentates. The cannons boom, the band plays, the press writes it all down, and they go indoors.

The true porch, or useful porch, incorporates some of that grandeur, but it is screened and protects you from prying eyes. It strikes a perfect balance between indoor and outdoor life.

Indoors is comfortable but decorous, as Huck Finn found out at the Widow's. It is even stifling if the company isn't right. A good porch gets you out of the parlor, lets you smoke, talk loud, eat with your fingers—without apology and without having to run away from home. No wonder that people with porches have hundreds of friends.

Of useful porches there are many sorts, including the veranda, the breezeway, the back porch, front porch, stoop, and now the sun deck, though the veranda is grander than a porch need be and the sun deck is useful only if you happen to like sun. A useful porch may be large or not, but ordinarily it is defended by screens or large shrubbery. You should be able to walk naked onto a porch and feel only a slight thrill of adventure. It is comfortable, furnished with old stuff. You should be able to spill your coffee anywhere without a trace of remorse . . .

The porch promotes grace and comfort. It promotes good conversation simply by virtue of the fact that on a porch there is no need for it. Look at the sorry bunch in the living room standing in little clumps and holding drinks, and see how hard they work to keep up a steady dribble of talk.

Willimantic, Connecticut

There, silence indicates boredom and unhappiness, and hosts are quick to detect silence and rush over to subdue it into speech. Now look at our little bunch on this porch. Me and the missus float back and forth on the swing, Mark and Rhonda are collapsed at opposite ends of the couch, Malene peruses her paperback novel in which an astounding event is about to occur, young Jeb sits at the table gluing the struts on his Curtiss biplane. The cats lie on the floor listening to birdies, and I say, "It's a heck of a deal, ain't it, a *heck* of a deal." A golden creamy silence suffuses this happy scene, and only on a porch is it possible.

—*from* "O THE PORCH"
by Garrison Keillor

*A*t one time, I was unaware of curtains. They were commonplace,—a constant of every European home. Now that I live in a city without curtains, I am enthralled when I see them. If windows are the eyes of a house, curtains are its lashes.

Curtains create filters that soften from the inside, yielding only light and shadows from the street. They make reality a little unreal, certainly more poetic. When I look at the closed windows and the shadows behind them, I think of the old ladies who may have spent months embroidering their curtains and years spying on us through them.

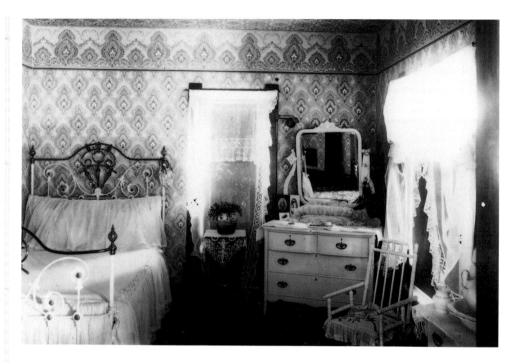

Neligh, Nebraska, circa 1910

Windows are truly a partition between worlds: the private world of the individual—one's home, one's intimate and secret environment—and the outside—the street, the crowd, the alien. Walls protect our intimacies but also blind; windows shelter and yet maintain worldly contact, by providing visual passages between the security of the known and the uncertainties of the unknown.

—*from* "EYES AND LASHES" *by Flavia Robinson Derossi*

62

*I*n Brownsville tene-
ments the kitchen is
always the largest room
and the center of the
household. As a child I
felt that we lived in a
kitchen to which four
other rooms were annexed
. . . The kitchen held our
lives together. My mother
worked in it all day long,
we ate in it almost all
meals except the Passover
seder, I did my homework
and first writing at the
kitchen table . . . The
kitchen gave a special
character to our lives; my
mother's character.

——*from* A WALKER IN THE
CITY *by Alfred Kazin*

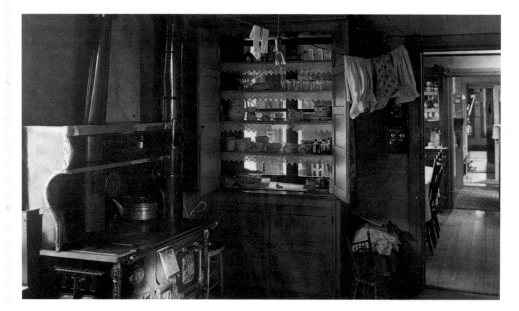

Madison, Minnesota, circa 1904

*H*ouses are always
the liveliest and
all that sort of thing
when the woman isn't
one of those awfully
good housekeepers.

——*John Oliver Hobbes*

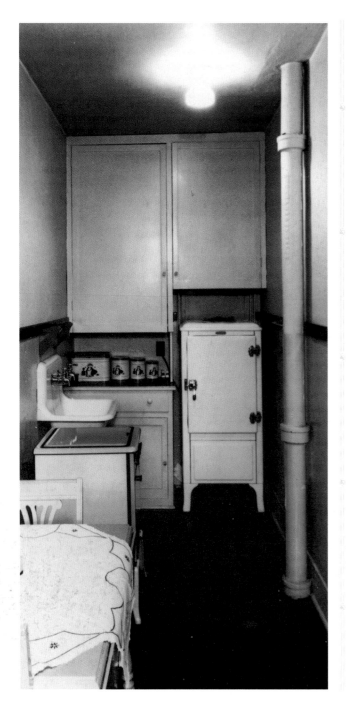

Lincoln, Nebraska, 1937

The cramped kitchenette is so small they always bumped into each other when they cooked. He used to stand behind her and bother her while she worked, press against her behind and reach around to touch her breasts while she was chopping parsley. The little refrigerator and stove are so old their white finish has deepened to a rich cream. He loves this kitchen. Its diamond-paned cupboard doors reaching to the ceiling, its deep old sink and mismatched faucets—it is like the good old kitchens, not the new magazine kitchens. He grew up in a house with the same refrigerator in its kitchen for twenty years, same stove, sink, breadbox, can opener on the wall. Now a kitchen isn't good for more than five years, the styles change. You had to have harvest gold or avocado. Then those were out and some new color was in, coppertone. Stainless steel. Almond. His mother's new kitchen is almond, with an island in it, and in the island a processing center, with attachments that screw in and chop or slice or grate

your food. Cuisinarts make people think life is eternal. Marcella whirring up a puree in that gleamy dazzly almond kitchen has not an inkling of what really is the end of all that preparation. But here—here in Claire's dark old kitchenette a shiver of recognition dances across his shoulders, the rich dark thickness of time moving toward an end.

—*from* DREAMS OF SLEEP *by Josephine Humphreys*

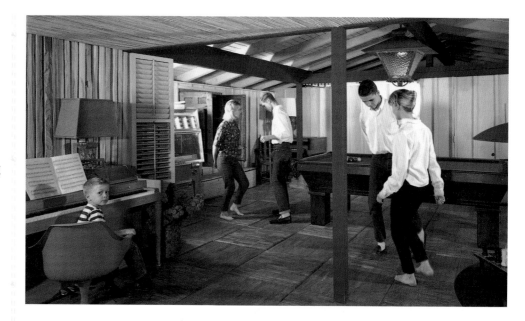

West Covina, California, circa 1960

*B*ut the real heart of the suburban bungalow of the '50s was the basement. It was in the basement that the apparent conventionality of suburban living was suspended and the personal idiosyncrasies of the family were let loose—in private. Here was the den, playroom, family room, or rec room, often decorated with an individual exuberance that would not have been out of place during the Gilded Age.

Looking back on it, I think I spent most of my time in this subterranean world. It was here that I had my train set, my modelmaking materials, and my puppet theater.

Dodging behind the furnace and the hot-water heater, my brother and I played swashbucklers with a pair of aluminum foils, or gangsters with tommy guns made from wood and lead pipe.

—*from* "HOME, SWEET BUNGALOW HOME" *by Witold Rybczynski*

*O*h, domesticity! The wonder of dinner plates and cream pitchers. You know your friends by their ornaments. You want everything. If Mrs. A. has her mama's old jelly mold, you want one, too, and everything that goes with it—the family, the tradition, the years of having jelly molded in it. We domestic sensualists live in a state of longing, no matter how comfortable our own places are.

—*from* THE LONE PILGRIM
by Laurie Colwin

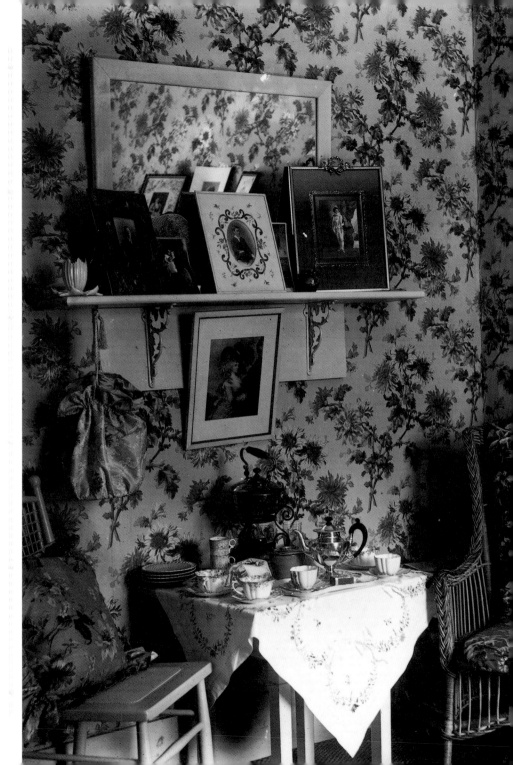

66

So many are the social qualities of flowers that it would be a difficult task to enumerate them. We always feel welcome when, on entering a room, we find a display of flowers on the table. Where there are flowers about, the hostess appears glad, the children pleased, the very dog and cat grateful for our arrival, the whole scene and all the personages seem more hearty, homely, and beautiful because of the bewitching roses, and orchids, and lilies, and mignonette!

—*from* RUSTIC ADORN-
MENTS FOR HOMES OF
TASTE *by Shirley Hibberd*

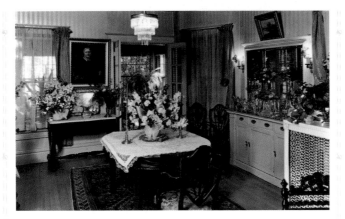

*Denver, Colorado,
circa 1945*

I, like you, live in my own workshop, putting this over there, trying that over here, a little to the left. My rooms are stuffed with what's seemingly semi-worthless, with the chipped, the tired-of-being-whimsical. You might think I've opened an orphanage for cast-off images, has-been bibelots, but those of us who hear the siren song of old things, new things, things damaged or unfinished, understand that we do not choose them any more than we can consciously pick those lovely worthless human paragons love makes us love. The few true things adopt us. The choicest things you've acquired—be they inherited, store-bought or street—prove once and for all: "inanimate object" is a contradiction in terms. Matter matters.

What three items would you save from your own burning home, think fast.

And, friend, in case of fire, know this—if they could move and weren't weighted by the awful burden of immortality that you and I have been lightly spared, you are the first thing those three favorite items would save. I believe, to them the sight of you means welcome, happiness, and use. For your own storied objects, you remain the sun, the organizing principle, the godlike visiting myth.

For your relics, you are home. Therein lies a tale . . .

—*from* "STORIED OBJECTS"
by Allan Gurganus

67

The Venetian mirror, eighteenth century, in a delicate scrolled gold frame, the glass clouded as if a ghostly breath had clouded it, had been a wedding present, the only thing Hilary had managed to keep with her from that time. It had hung in hotel rooms, in lodgings, in rented cottages in England, in Vermont, who knows where? For Hilary it kept the natural warmth of her marriage alive, far better than did the faded photographs of herself and Adrian in ridiculous dated clothes. So now what came vividly to her mind . . . was the morning when she and Adrian had first hung the mirror in their Chelsea flat. She remembered a beam of sunlight crossing its watery depths, and Adrian saying, "There, now we can invite a duchess to tea!"

—*from* MRS. STEVENS HEARS THE MERMAIDS SINGING *by May Sarton*

Block Island, Rhode Island

Neligh, Nebraska, circa 1900

Lee: Made a little tour this morning. She's got locks on everything. Locks and double-locks and chain-locks and— What's she got that's so valuable?

Austin: Antiques I guess. I don't know.

Lee: Antiques! Brought everything with her from the old place, huh. Just the same crap we always had around. Plates and spoons.

Austin: I guess they have personal value to her.

Lee: Personal value. Yeah. Just a lota' junk. Most of it's phony anyway. Idaho decals. Now who in the hell wants to eat offa' plate with the State of Idaho starin' ya' in the face. Every time ya' take a bite ya' get to see a little bit more.

Austin: Well it must mean something to her or she wouldn't save it.

Lee: Yeah, well personally I don't wanna' be invaded by Idaho when I'm eatin'. When I'm eatin' I'm home. Ya' know what I'm sayin'? I'm not driftin', I'm home. I don't need my thoughts swept off to Idaho.

—*from* "TRUE WEST" *by Sam Shepard*

Thoreau's cabin, reconstructed at Walden Pond, near Concord, Massachusetts

I had three chairs in my house: one for solitude, two for friendship, three for society.

—*Henry David Thoreau*

*D*on't own so much clutter that you will be relieved to see your house catch fire.

—*from* "PRAYERS AND SAYINGS OF THE MAD FARMER" *by Wendell Berry*

69

Although as a rule I hate housework, here I take erratic fits of domesticity, born of a compulsion to feel this house under my palms, to scour and polish and perfect it somehow: the only way to communicate love to a house.

—*from* REMEMBERING THE BONE HOUSE *by Nancy Mairs*

The beauty of the house is order,

The blessing of the house is contentment,

The glory of the house is hospitality.

—*Anonymous*

San Diego, California, circa 1922

But there are women who do like to keep house; and if they live in a house, factitious cares like window washing and rug shaking and bouquet replenishing will constantly tempt them. I am one of these women. Sweep, mop, shake rugs, make beds, dust. I can even get a little rhythm into dishwashing. It is a housework dance, and if you have danced it well, you will also, when you finish, have painted a

picture: the still life that, when the candles are lit, will cause the picture in the eye of its maker and solitary beholder to blossom into a luminous universe, its tendrils extending into every vein of his body . . .

The stove does not much tempt me. When I was young, I thought that there was enough time in life for marble cakes and hermits and pigs in blankets. I have begun to doubt it. I make time . . . for dusting and scrubbing and gathering flowers. I do this because I live in my eyes and because bending and twisting— what is called big muscle work—exhilarates me. Finger work, which is

what cooking requires, I do not care for. To feed a hungry family, yes, but not for pleasure . . .

The house cleaner is, compared with the cook, selfish. The cook cooks for others, to give them pleasure. I don't clean house, "put a room to rights," to please others. I do it for myself. It does for my soul what prayer

does for others. And it takes so much less faith. House ordering is my prayer, and when I have finished, my prayer is answered. And bending, stooping, scrubbing, purifies my body as prayer doesn't . . .

The woman who makes a house say welcome *may* do so for the pleasure of family and friends. She

does not, however, expect her still life, though it may be slightly askew at the end of the day, to be totally destroyed. But that's what happens to the pot roast and the black-bottom pie. That's what they were made for: total destruction.

—*from* HIDE AND SEEK *by Jessamyn West*

Wapato, Washington, 1939

Hidalgo, Texas, 1939

I . . . oversee the interior of the house or, at any rate, do the housework. I hope I don't sound disingenuous by saying I enjoy housework; its very repetitiveness and the solace of its tangible qualities are in such contrast to the uncontrollable movements of the imagination. Picasso may not have been talking about the eccentric pleasures of housework when he said nothing interested him more than the movement of his own thoughts, or Oscar Wilde when he asserted he was never bored when by himself, but they were certainly speaking of the eccentric urgings of the introverted personality: happiest in a "home" of its own invention. Indeed I would be distinctly unhappy to see someone else cleaning our house, dreamily vacuuming, washing windows, usurping my place, my solitude.

—*from "*PRINCETON PASTORAL*" by Joyce Carol Oates*

A woman's work is never done.

—*Anonymous*

*O*kay. The major issue facing a man and a woman who decide to live together is: Dirt. I am serious. Men and women do not feel the same way about dirt at all. Men and women don't even *see* dirt the same way. Women, for some hormonal reason, can see individual dirt molecules, whereas men tend not to notice them until they join together into clumps large enough to support commercial agriculture. There are exceptions, but over 85 percent of all males are legally classifiable as Cleaning Impaired.

This can lead to serious problems in a relationship. Let's say a couple has decided to divide up the housework absolutely even-steven. Now when

it's the woman's turn to clean, say, the bathroom, she will go in there and actually clean it. The man, on the other hand, when it's his turn, will look around, and, because he is incapable of seeing the dirt, will figure nothing major is called for, so he'll maybe flush the toilet and let it go at that. Then the woman will say: "Why didn't you clean the bathroom? It's *filthy!*" And the man, whose concept of "filthy" comes from the men's rooms in bars, where you frequently see bacteria the size of cocker spaniels frisking around, will have no idea what she's talking about.

—*from* DAVE BARRY'S GUIDE TO MARRIAGE AND/OR SEX *by Dave Barry*

Brooklyn, New York, 1886

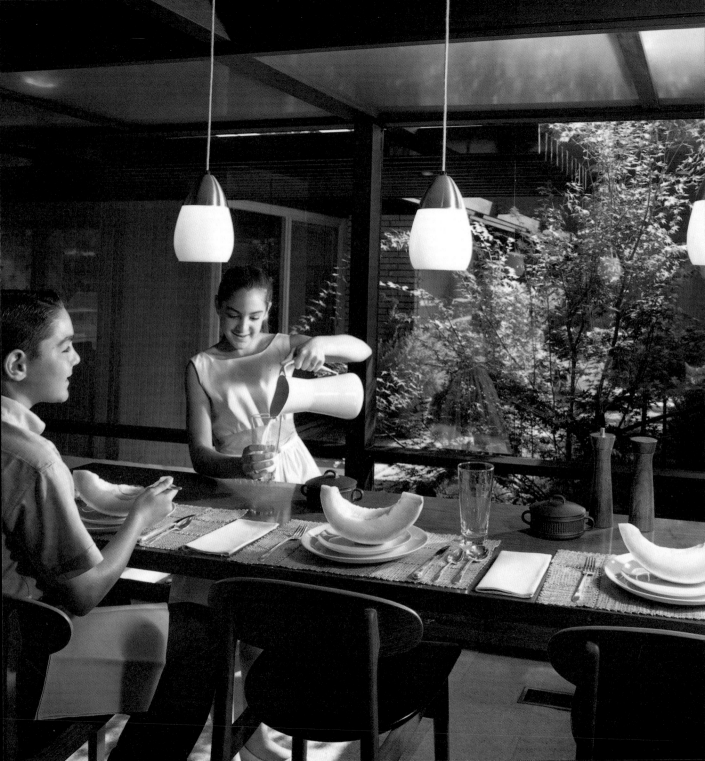

A clean, fresh, and well-ordered house exercises over its inmates a moral, no less than physical influence, and has a direct tendency to make members of the family sober, peaceable, and considerate of the feelings and happiness of each other.

—*from* OUR HOMES AND HOW TO MAKE THEM HEALTHY *by Shirley Murphy*

*B*eauty commonly produces love, but cleanliness preserves it.

—*Joseph Addison*

Washington, D.C.

*H*ominess is not neatness. Otherwise everyone would live in replicas of the kinds of sterile and impersonal homes that appear in interior-design and architectural magazines. What these spotless rooms lack, or what crafty photographers have carefully removed, is any evidence of human occupation. In spite of the artfully placed vases and casually arranged art books, the imprint of their inhabitants is missing. These pristine interiors fascinate and repel me. Can people really live without clutter? How do they stop the Sunday papers from spreading over the living room? How do they manage without toothpaste tubes and half-used soap bars in their bathrooms?

—*from* HOME: A SHORT HISTORY OF AN IDEA *by Witold Rybczynski*

Los Angeles, California, 1960

*T*his life I lead, setting pictures straight, squaring rugs up with the room—it suggests an ultimate symmetry toward which I strive and strain. Yet I doubt that I am any nearer my goal than I was last year, or ten years ago, even granted that this untidy world is ready for any such orderliness. Going rapidly through the hall, on an errand of doubtful import to God and country, I pause suddenly, like an ant in its tracks, and with the toe of my sneaker shift the corner of the little rug two inches in a southerly direction, so that the edge runs parallel with the floor seams. Healed by this simple geometry, I continue my journey.

The act, I can only conclude, satisfies something fundamental in me, and if, fifteen minutes later on my way back, I find that the rug is again out of line, I repeat the performance with no surprise and no temper. Long ago I accepted the fact of the rug's delinquency; it has been a pitched battle and the end is not in sight. At least one of my ancestors died lunging out of bed at the enemy, and it is more than likely that I shall fall at last, truing up a mediocre mat.

—*from* "REMOVAL"
by E. B. White

Santa Fe, New Mexico,
circa 1935

*H*ere lies a poor woman who always was tired,

She lived in a house where help wasn't hired.

The last words she said were: "Dear friends, I am going,

Where washing ain't wanted, nor sweeping nor sewing.

And everything there is exact to my wishes,

For where folks don't eat there's no washing of dishes.

In heaven loud anthems forever are ringing,

But having no voice I'll keep clear of the singing.

Don't mourn for me now, don't mourn for me never,

I'm going to do nothing for ever and ever."

—*Anonymous*

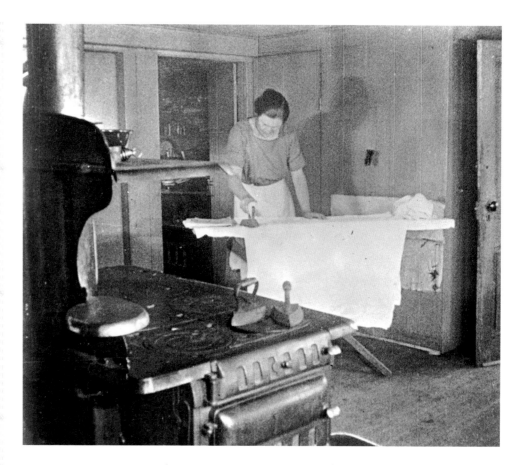

Saint Paul, Minnesota, circa 1920

*H*ome is the girl's prison and the woman's workhouse.

—*from* MAN AND SUPERMAN *by George Bernard Shaw*

77

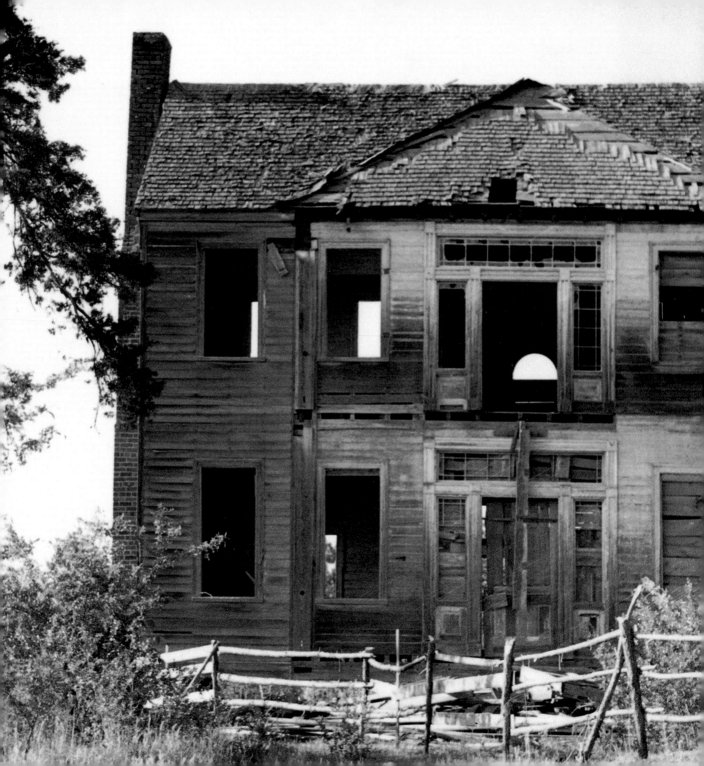

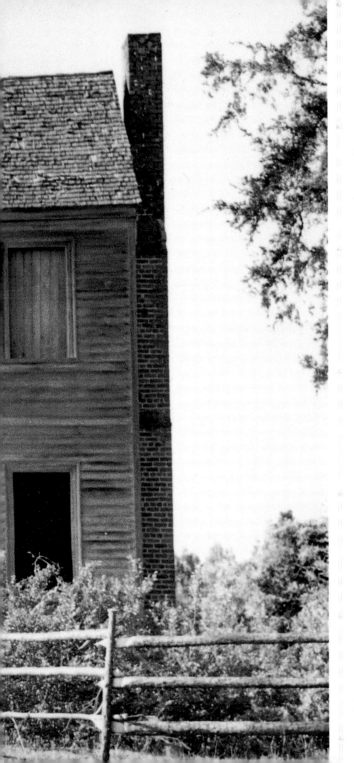

"Houses have their own
ways . . ."

Near Monticello, South Carolina, 1939

*H*ouses have their own ways of dying, falling as variously as the generations of men, some with a tragic roar, some quietly, but to an after-life in the city of ghosts, while from others —and thus was the death of Wickham Place—the spirit slips before the body perishes. It had decayed in the spring, disintegrating the girls more than they knew, and causing either to accost unfamiliar regions. By September it was a corpse, void of emotion, and scarcely hallowed by the memories of thirty years of happiness. Through its

round-topped doorway passed furniture, and pictures, and books, until the last room was gutted and the last van had rumbled away. It stood for a week or two longer, open-eyed, as if astonished at its own emptiness. Then it fell. Navvies came, and spilt it back into the grey. With their muscles and their beery good temper, they were not the worst of undertakers for a house which had always been human, and had not mistaken culture for an end.

—*from* HOWARDS END *by* E. M. Forster

*I*t is said that people who have never known one or both of their parents nor who they were are piqued by curiosity about them all their lives, and that there is even an organization of these adult orphans who assist one another in their search for their lost mothers and fathers, or for any scrap of knowledge about them; I can well understand that urge: I felt something akin to it about the house I was born in, and which had been torn down shortly after my birth. My longing for this nonexistent house, instead of lessening as I got older and presumably more sensible, actually grew; for it ceased to be a longing for a house and became a longing for a state of being which the house had come to symbolize for me . . .

I did not even know where in Clarksville the house I was born in had stood, for, from her unwillingness to talk about it, I sensed that to my mother, as to me, the destruction of that house was saddening, and so I did not pester her. After that house which I never knew was joined by the one whose destruction I had endured, in which I lost all my toys, my keepsakes, all our family photographs except for the few that relatives had other prints of, in which were burned all the mementoes of my first ten years—links to one's former selves, saved in order to connect our stages (larva, pupa, chrysalis) into one continuous growth, in a vain effort to go into the grave intact, one person—I mourned for it still more.

—*from* FARTHER OFF FROM HEAVEN *by* William Humphrey

Pittsburgh, Pennsylvania, 1951

*T*he gleam of the candle mounted the dark stairs and stirred the shadows of the long low attics. There was no colour up here, neither velvets nor gilding; nothing but plaster and grey oak the colour of ashes. Anquetil preferred this bareness to the sumptuous rooms downstairs; he thought he saw the bones of the house stripped of their flesh; and indeed these silvery galleries recalled the pallor of a skeleton . . . the house is dying from the top; this uppermost floor is deserted wholly, and all the cheerful bustle has departed from it; it lies stretched in the ashen hues of mortality, immediately below the roof that thinly divides it from the sky.

—*from* THE EDWARDIANS *by Vita Sackville-West*

*N*ext day I reached my parents' house, where my stepbrothers and their wives, my brother and his wife, my sister and her husband awaited me for the burial, the reading of the will and the apportioning of property. In the days that followed the final disintegration of the family was completed. A desecration and crushing underfoot took place, full of the undertones of envy and avarice although outwardly we tried to preserve a friendly and considerate tone of cordial agreement. Even for us, although we had long since become alienated from them, all the articles collected there had their value, and suddenly a wealth of recollections attached itself to each item. The grandfather clock with the sun face had ticked its way into my earliest dreams, in the mirror of the huge wardrobe I had caught sight of myself in the moonlight during my nocturnal excursions, in the diagonal supports beneath the dining-room table I had built dens and dugouts, and had crept behind the rotting velvet curtains to escape the savage pine marten, and many of the books on the high, wide bookshelves contained secret, forbidden things to read. We pushed and shoved around the chairs, sofas, and tables, violently we disrupted the order that had always been unassailable, and soon the house resembled a furniture warehouse and the objects that had been afforded a lifetime's care and protection at my mother's hand lay piled up in various rooms in five huge heaps, some to be taken away, some to be sold.

—*from* EXILE *by Peter Weiss*

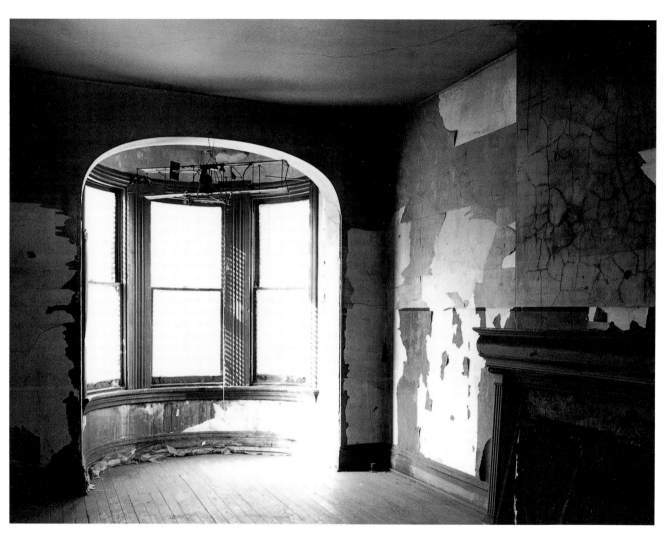

Washington, D.C.

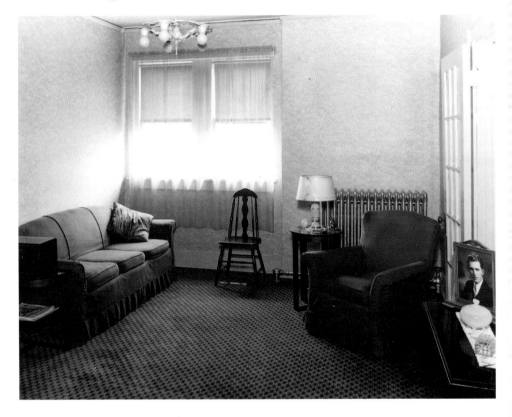

*T*here was but one thing wrong with the Babbitt house, it was not a home.

—*from* BABBITT
by Sinclair Lewis

*H*owever hard and bitter, however hampering and threatening the lack of houses remains, the *real plight of dwelling* does not lie merely in a lack of houses. The real plight of dwelling is indeed older than the world wars with their destruction, older also than the increase of the earth's population and the condition of the industrial workers. The real dwelling plight lies in this, that mortals ever search anew for the essence of dwelling, that they *must ever learn to dwell*.

—*from* "BUILDING DWELLING THINKING"
by Martin Heidegger

They say Home . . . is where when you go . . . they have to take you in. I rather prefer Home . . . when you could go anywhere . . . is the place you prefer to be. I don't think of a home as a house, which is another thing I don't own. Certainly, though, I do live in a house that I have made my home. I won't even pretend living on the streets, sleeping in public parks, washing up at the bus or train station, eating out of garbage cans is a valid alternative to bedrooms, bathrooms and kitchens whiffing good smells every time the furnace blows. But I also readily concede if there is no love a building will not compensate.

—*from* SACRED COWS . . . AND OTHER EDIBLES *by Nikki Giovanni*

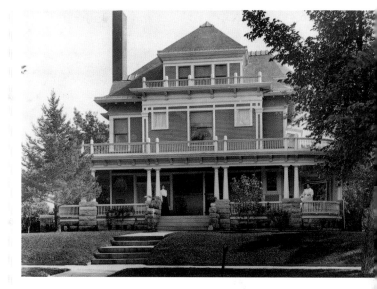

Lincoln, Nebraska, 1902

New York, New York

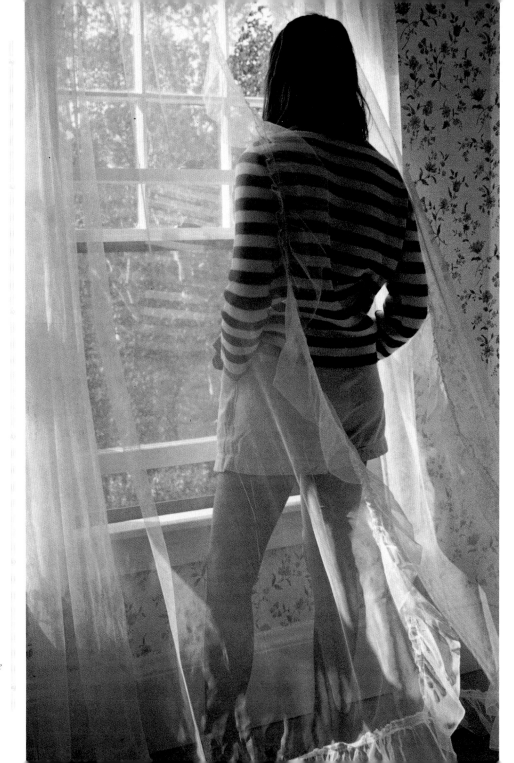

*W*hen you dwell in a house you dislike, you will look out of a window a great deal more than those who are content with their dwelling.

—*from* PRECIOUS BANE
by Mary Webb

Biddeford Pool, Maine

When he needs to get away from everything, he drives out to his ranch, an hour north of Los Angeles. He has thirty acres and a stable with twenty horses. There are two grooms, young men doing the kind of work he once dreamed of doing. There's also a small white house, the kind of house he might have aspired to live in if none of this had happened to him. Neither of his two wives ever wanted to stay here.

Whenever he comes to this house, he thinks of small houses he lived in years ago. His memories of them are oddly vivid. "I can recall every nook and cranny. I have lived in mansions, and I don't recall one aspect of the rooms, other than the color of the furniture."

It's late in the afternoon when he enters that house, accompanied by his contractor. The house is being renovated, and its rooms are empty. The contractor tells him he needs a new stove, a new refrigerator. He shakes his head. He looks tired. "I buy all this equipment," he says, "I never use it, and the next thing I know I'm replacing it."

The contractor leaves. Stallone stays behind, looking out the living room's picture window. Then his dark eyes take in the empty room. They look huge and solemn.

When he was a child, and left alone most of the time, he would come home and lie on the living-room floor. "It was a very small room," he remembers, "and I would lie there in the warm light that came through the window, and I would watch specks of dust fall. Like snow. I felt more secure in that light than I did in my own bed. And I would lie there for hours." And sometimes he would climb out of a window and sit on the roof of the house and say to himself, "You can't get any higher in the world."

At those moments, everything seemed simple, and he'd be content. That was long ago. "There'll be no sense of peace ever," he says now. "I've definitely brought myself to that conclusion. This is one business where you can be absolutely sure your star will fall. Newton's law is applied here with a vengeance. It makes me sad. It's a lot like an addict. It's gonna be very hard to kick the habit. But it's been an extraordinary life. I just wish that I had been there to enjoy it."

He turns from the window. Outside, the light is fading. He walks out of the house. He shuts the door behind him.

"I still think of myself sometimes," he says, "as a guy who lived behind windows."

—*from* "SLY'S PROGRESS," *an interview with Sylvester Stallone by Elizabeth Kaye*

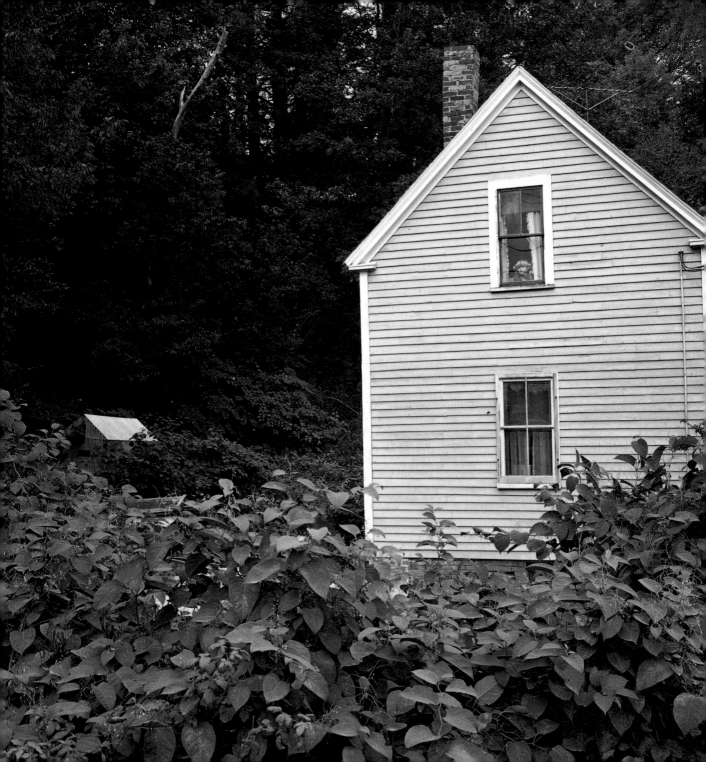

*N*ear their apartment building was a large baseball field, rarely used. From Gerard's living-room window he could see the field's old rotting scoreboard, weathered as driftwood, its paint peeling but still boasting the neat and discernible lettering: HOME and VISITOR. When he'd first moved into the apartment, the words seemed to mock him—scoring, underscoring, his own displacement and aloneness—so much that he would close the blinds so as not to have to look at them . . . More and more he was becoming convinced that it was only through children that one could connect with any-thing anymore, that in this life it was only through children that one came home, became a home, that one was no longer a visitor.

—*from* ANAGRAMS *by Lorrie Moore*

I had lived with family until my son was born in my sixteenth year. When he was two months old and perched on my left hip, we left my mother's house and together, save for one year when I was touring, we had been each other's home and center for seventeen years. He could die if he wanted to and go off to wherever dead folks go, but I, I would be left without a home.

—*from* ALL GOD'S CHIL-DREN NEED TRAVELING SHOES *by Maya Angelou*

Quincy, Massachusetts

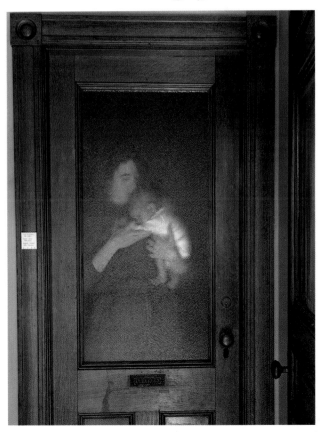

Topsham, Maine

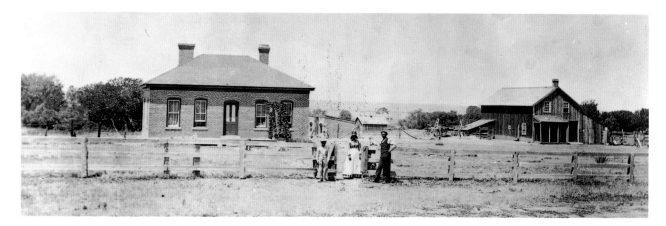

Douglas County, Colorado

In the nineteenth century the American "home" was a clouded image. Foreign visitors commented on the fact that Americans had little or no feeling for "home"—that ancient, magic word—as a *place*. A home, traditionally, is an accretion of sounds, sights, experiences, textures; it is a kind of stage, a particular recognizable setting, against which the principal dramas of ordinary life are played out. But American homes were mobile long before they were put out on wheels. Home is not a castle, a refuge, a bower, an ancestral manor—it is "where you hang your hat." You hang it here today and there tomorrow. "You can't go home again," not simply because home is no longer there psychologically, as in the case of Thomas Wolfe; it is not even there physically.

—*from* DAUGHTERS OF THE PROMISED LAND *by Page Smith*

You can actively flee, then, and you can actively stay put; you even can . . . "actively hide." On the other hand, you can feel uprooted if you are not permitted to roam perpetually, as witness the remnants of the American Plains Indians, who, on their own prairie, were forced to abandon nomadic life. Long after the government had settled them in frame houses, they asked for trailers to live in. Not permitted to perambulate at will, they developed in their actions and in their speech that same intangible drag of a slow-motion picture which is typical of depressed individuals . . . The tribal identity of the nomadic hunters had developed its roots in perpetual motion.

—*from* INSIGHT AND RESPONSIBILITY *by Erik H. Erikson*

Ute tribespeople and dwellings, Colorado, 1899

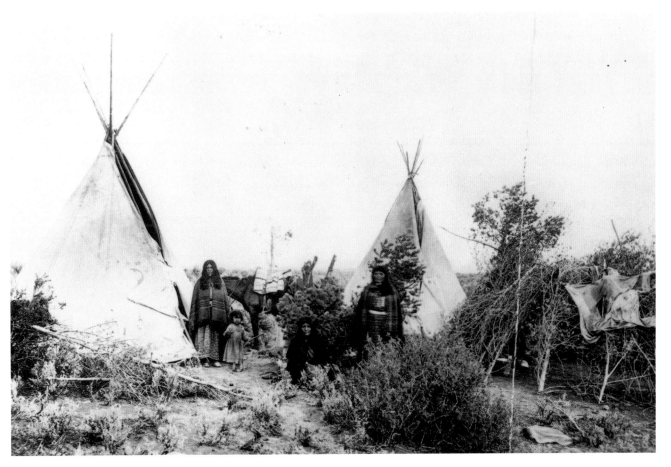

The House of the Seven Gables, Salem, Massachusetts

"I should scarcely call it an improved state of things," observed Clifford's new acquaintance, "to live everywhere, and nowhere!"

"Would you not?" exclaimed Clifford, with singular energy. "It is as clear to me as sunshine . . . that the greatest possible stumbling-blocks in the path of human happiness and improvement, are these heaps of bricks, and stones, consolidated with mortar, or hewn timber, fastened together with spike-nails, which men painfully contrive for their own torment, and call them house and home! The soul needs air; a wide sweep and frequent change of it. Morbid influences, in a thousand-fold variety, gather about hearths, and pollute the life of households. There is no such unwholesome atmosphere as that of an old home, rendered poisonous by one's defunct forefathers and relatives!

—*from* THE HOUSE OF THE SEVEN GABLES *by Nathaniel Hawthorne*

He crosses the front room, which he calls his study, and comes down the staircase. The stairs turn a corner; they are narrow and steep. You can touch both handrails with your elbows, and you have to bend your head, even if, like George, you are only five eight. This is a tightly planned little house. He often feels protected by its smallness; there is hardly room enough here to feel lonely.

Nevertheless . . .

Think of two people, living together day after day, year after year, in this small space, standing elbow to elbow cooking at the same small stove, squeezing past each other on the narrow stairs, shaving in front of the same small bathroom mirror, constantly jogging, jostling, bumping against each other's bodies by mistake or on purpose, sensually, aggressively, awkwardly, impatiently, in rage or in love—think what deep though invisible tracks they must leave, everywhere, behind them! The doorway into the kitchen has been built too narrow. Two people in a hurry, with plates of food in their hands, are apt to keep colliding here. And it is here,

nearly every morning, that George, having reached the bottom of the stairs, has this sensation of suddenly finding himself on an abrupt, brutally broken off, jagged edge—as though the track had disappeared down a landslide. It is here that he stops short and knows, with a sick newness, almost as though it were for the first time: Jim is dead. Is dead.

—*from* A SINGLE MAN *by Christopher Isherwood*

New London, Wisconsin, circa 1915

*E*verybody's always talking about people breaking into houses . . . but there are more people in the world who want to break out of houses . . .

—*from* "THE MATCHMAKER" *by Thornton Wilder*

*H*ow do you enter your own house when something has gone bad on the inside, when it doesn't seem like your place to live any more, when you almost cannot recall living there although it was the place where you mostly ate and slept for all your grownup life? Try to remember two or three things about living there. Try to remember cooking one meal. . . . Sometimes there is no choice but to walk into your own house. . . . There is the moment when you walk in and take a look in your house, like any traveler.

—*from* "THE SOAP BEAR" *by William Kittredge*

Louisville, Kentucky, 1920

Gold & Company Department Store, Lincoln, Nebraska, 1948

The modern home is so destructive, I think, because it is a generalization, a product of factory and fashion, an everyplace or a noplace. Modern houses, like airports, are extensions of each other; they do not vary much from one place to another. A person standing in a modern room anywhere might imagine himself anywhere else—much as he could if he shut his eyes. The modern house is not a response to its place, but rather to the affluence and social status of its owner. It is the first means by which the modern mentality imposes itself upon the world. The industrial conquistador, seated in his living room in the evening in front of his TV set, many miles from his work, can easily forget where he is and what he has done. He is everywhere or nowhere. Everything around him, everything on TV, tells him of his success: *his* comfort is the redemption of the world. His home is the emblem of his status . . .

This generalized sense of worldly whereabouts is a reflection of another kind of bewilderment: this modern person does not know where he is morally either.

—*from* THE UNSETTLING OF AMERICA *by Wendell Berry*

You can't go home again.

— *Thomas Wolfe*

95

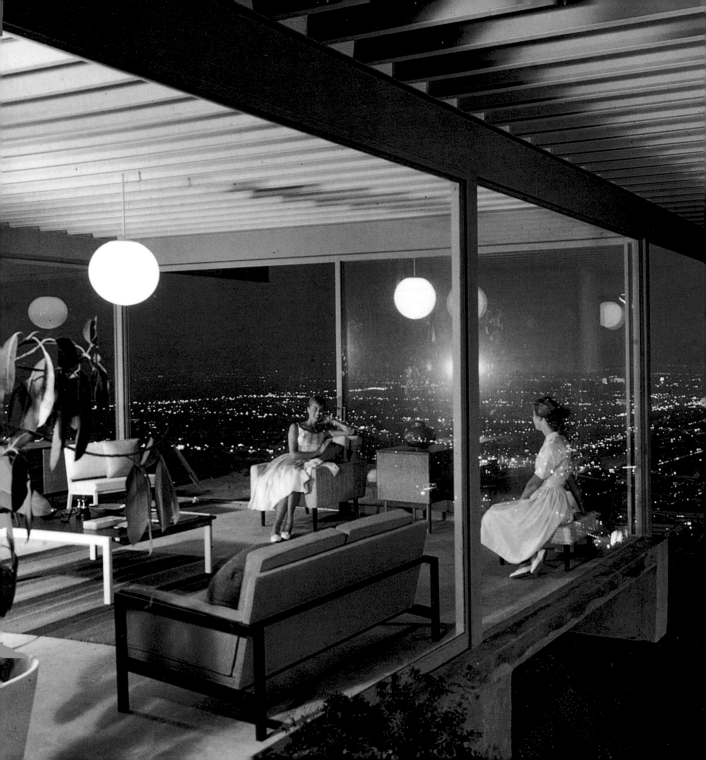

"*In a house which loves you,
all things are possible . . .*"

Los Angeles, California, 1960

*B*irds cannot fly over it.

It is only as tall as I dictate.

One word from me, and the windows

open good-naturedly, doors close

off the unused rooms, or perhaps

the cellar loses its water.

I should imagine it would do

what imitations I tell it to;

I shall possess it.

And in it we will tend to

the doing of the days

with a new sense of righteousness.

O all the order by accident—

the coverings and the pretty pictures,

the authenticity of the materials!

And O the penny-color pronouncements!

I shall work its makers hard

to create an approving environment

for whatsoever I may choose

or henceforth be seized by.

Hereafter, let fantasy be exposed

for a common denominator.

For I shall live in this house

as the actress of my dreams,

in a house that invites my playing.

And I shall be the first instance

of health, gathering my split dreams

under the flag of abandonment.

In a house which loves you,

all things are possible.

—"HER DREAM HOUSE" *by Marvin Bell*

Lincoln, Nebraska, 1945

At a certain season of our life we are accustomed to consider every spot as the possible site of a house. I have thus surveyed the country on every side within a dozen miles of where I live. In imagination I have bought all the farms in succession, for all were to be bought, and I knew their price. I walked over each farmer's premises, tasted his wild apples . . . took his farm at his price, at any price, mortgaging it to him in my mind; even put a higher price on it,—took everything but a deed of it . . . This experience entitled me to be regarded as a sort of real-estate broker by my friends. Wherever I sat, there I might live, and the landscape radiated from me accordingly. What is a house but a *sedes*, a seat? —better if a country seat. I discovered many a site for a house not likely to be soon improved, which some might have thought too far from the village, but to my eyes the village was too far from it. Well, there I might live, I said; and there I did live, for an hour, a summer and a winter life; saw how I could let the years run off, buffet the winter through, and see the spring come in. The future inhabitants of this region, wherever they may place their houses, may be sure that they have been anticipated.

—*from* WALDEN *by Henry David Thoreau*

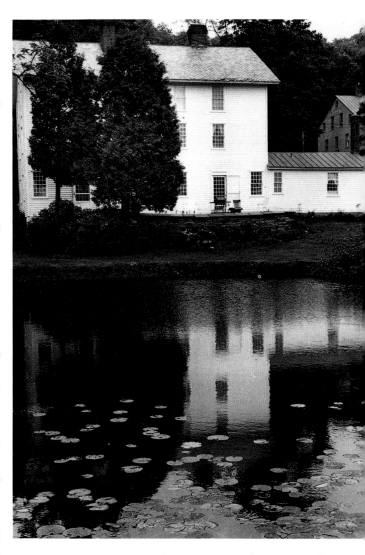

New Lebanon, New York

enry James, who knew a great deal, if not everything, considered these two words the most perfectly beautiful in English: "summer afternoon." My own favorite since childhood is just "Home." I love the way its stately gate of an "H" swings open onto the shielded domesticity of roundnesses, the way Home's little "e" stands, back-looking, bye-saying, like the household's child sent out to wave company safe into the night. That last sentence, playing house with the letters of one word, shows both my novelist's trade—making something of seemingly nothing much—and the reason my rooms look the way they do—that overloaded, overheated alphabet, my home.

—*from* "STORIED OBJECTS" *by Allan Gurganus*

San Diego, California

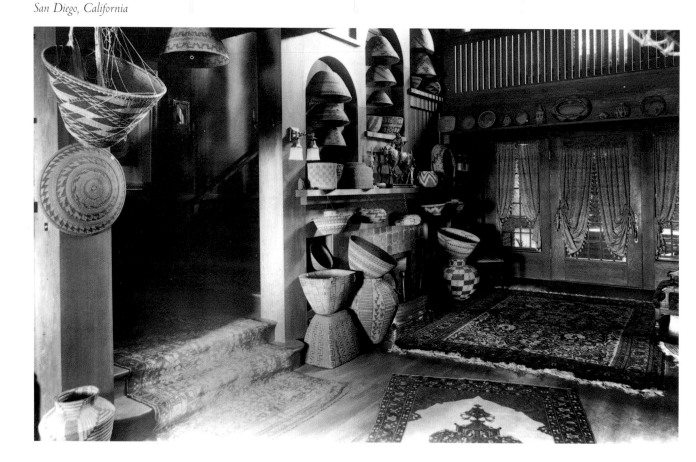

Not long ago, my sister returned to me a bundle of my letters to her, dated from my nineteenth year. My life has been, to say the least, varied: I have lived in five countries and traveled in several more. But at recurring intervals I wrote, in all seriousness: "Next year I shall find a little house in the country and settle there." Meantime I was looking at little houses in the country, all sorts of houses in all sorts of countries.

I shopped with friends in Bucks County long before that place became the fashion. I chose a perfect old stone house and barn sitting on a hill there, renovated it splendidly, and left it forever, all in one fine June morning. In this snapshot style, I have also possessed beautiful old Texas ranch houses; a lovely little Georgian house in Alexandria, Virginia; an eighteenth-century Spanish-French house in Louisiana . . .

There was never, of course, much money, never quite enough; there was never time, either; there was never permanency of any sort, except the permanency of hope.

—*from* "A HOUSE OF MY OWN" *by Katherine Anne Porter*

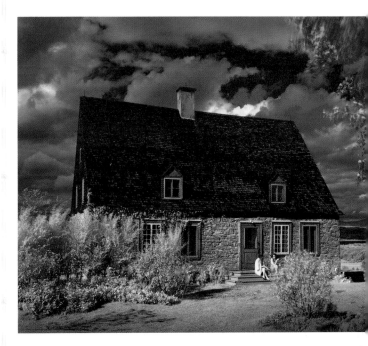

Ile D'Orlean, Quebec Province, Canada

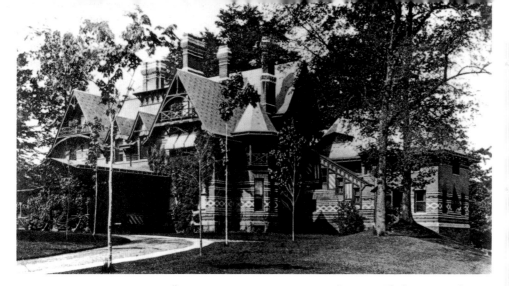

*T*o us, our house was not an unsentient matter—it had a heart, and a soul, and eyes to see us with; and approvals, and solicitudes, and deep sympathies; it was of us, and we were in its confidence, and lived in its grace and in the peace of its benediction. We never came home from an absence that its face did not light up and speak out its eloquent welcome—and we could not enter it unmoved.

—*from a letter (1897) by Mark Twain*

I love the house here as though it were an entity, a living and active presence, aloof but benign, its being in a tension of desire with my being, a body other than but like my body. Not that I don't think of it as a structure of wood and plaster and glass, but that these substances seem to me to serve as well for making a desirable being as do bone and blood. The passion that I feel for this house will mold my relationship to every other space I occupy, just as my passion for a dark-haired, slender boy named James Hopper will teach me how I'll be with men. First love.

—*from* REMEMBERING THE BONE HOUSE *by Nancy Mairs*

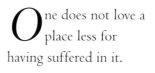

The home of Mark Twain, Hartford, Connecticut

*O*ne does not love a place less for having suffered in it.

—*Jane Austen*

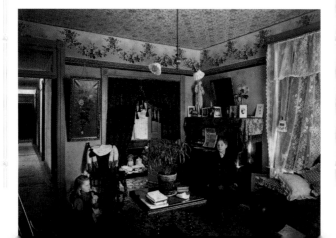

Madison, Minnesota, 1904

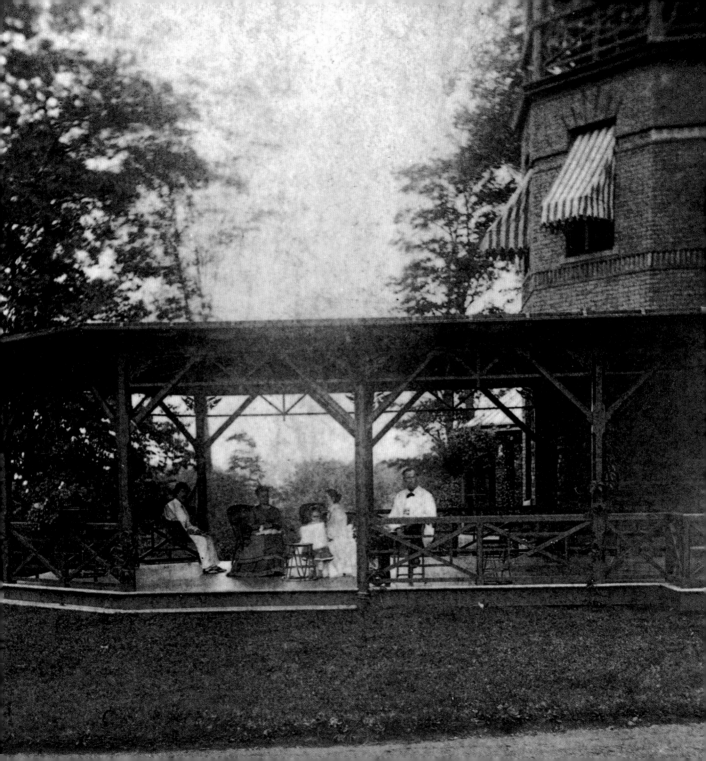

If I were asked to name the chief benefit of the house, I should say: the house shelters day-dreaming, the house protects the dreamer, the house allows one to dream in peace.

—*from* THE POETICS OF SPACE *by Gaston Bachelard*

Friends sometimes think excessive the pleasure I get from my house in North Wales, which is called Trefan Morys partly after the ancient estate that surrounds it and partly after me. I love it above all inanimate objects and above a good many animate ones, too. I love it incessantly. When I am at home I wander around its room gloatingly: when I am away I lie in my hotel dreaming of it. If people show me pictures of their children, I show them pictures of my house, and there is nothing on earth I would swap it for, except possibly something by Giorgione.

Freudian amateurs, which friends so often are, find this preoccupation unnatural. It has a psychoobsessive ring, they say. It shows a womb longing— even a death wish, they sometimes add, especially when they learn that my gravestone already stands in a corner of my library. It is a kind of fetish— one might as well be in love with a washing

Plano, Texas

machine or a stamp collection. But I see my passion in a different way. I love the house not just as a thing but as a concentration of emotions and sensations contained within a receptacle which in its style, its stance, its materials, its degree of grandeur, and its position on the map exactly represents all that I have most cherished or coveted in life. The house is not at all large, luxurious, or spectacular yet the sultan of Brunei could not build it, for it is infinitely more than the sum of its own modest parts. In my mind it is almost a metaphysical house, and Fate indeed chose it for me . . .

—*from* PLEASURES OF A TANGLED LIFE *by Jan Morris*

*T*he value of a house in human terms—its safety, its underpinning of family continuity, its usefulness in the physical business of day-to-day living—is largely determined by the community of which it is a part, by the physical qualities of that community, roads, water, drains, power; by its psychic gifts—education and culture and beauty— with bodily health as the link between material and spiritual gifts. For the vast majority of the human race, shelter as such can hardly be distinguished from these wider services. If they are in good order, the simplest shack is a home. Without them, an elegant villa can be an unsanitary trap.

—*from* THE HOME OF MAN *by Barbara Ward*

Lincoln, Nebraska, 1924

Woodstock, New York

The barrenness of the kitchen she was standing in made Martha reflect on the richness of domestic artifact. What a good shield a house is, emblazoned everywhere with the message that shared, daily life was lived within . . .

—*from* THE LONE PILGRIM *by Laurie Colwin*

A comfortable house is a great source of happiness. It ranks immediately after health and a good conscience.

—*from a letter to Lord Murray (1843) by Sydney Smith*

Plano, Texas

The sensation of shelter, of being out of the rain, but *just* out. I would lean close to the chill windowpane to hear the raindrops ticking on the other side . . . I loved doorways in a shower. On our side porch, it was my humble job, when it rained, to turn the wicker furniture with its seats to the wall, and in these porous woven caves I would crouch, happy almost to tears, as the rain drummed on the porch rail and rattled the grape leaves of the arbor and touched my wicker shelter with a mist like the vain assault of an atomic army.

. . . The reader may notice, the experiencer is motionless, holding his breath as it were, and the things experienced are morally detached from him: there is nothing he can do, or ought to do, about the flow, the tumult. He is irresponsible, safe, and witnessing.

—*from*
SELF-CONSCIOUSNESS
by John Updike

satisfaction of the house more than of the family . . . In the Indian gazettes a wigwam was the symbol of a day's march, and a row of them cut or painted on the bark of a tree signified that so many times they had camped. Man was not made so large limbed and robust but that he must seek to narrow his world, and wall in a space such as fitted him. H was at first bare and out of doors; but though this was pleasant enough in serene an warm weather, by daylight,

As for a Shelter, I will not deny that this is now a necessary of life, though there are in-stances of men having done without it for long periods in colder coun-tries than this . . . But, probably, man did not live long on the earth without discovering the convenience which there is in a house, the domestic comforts, which phrase may have originally signified the

Terlingua, Texas

the rainy season and the winter, to say nothing of the torrid sun, would perhaps have nipped his race in the bud if he had not made haste to clothe himself with the shelter of a house. Adam and Eve, according to the fable, wore the bower before other clothes. Man wanted a home, a place of warmth, or comfort, first of physical warmth, then the warmth of the affections.

—*from* WALDEN *by Henry David Thoreau*

She gave herself up to the feeling of being at home. It went all through her, that feeling, like getting into a warm bath when one is tired. She was safe from everything, was where she wanted to be, where she ought to be. A plant that has been washed out by a rain storm feels like that, when a kind gardener puts it gently back into its own earth with its own group.

—*from* "THE BEST YEARS" *by Willa Cather*

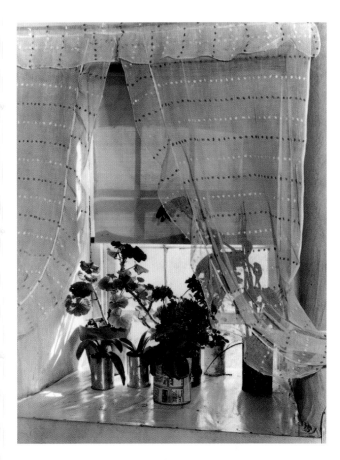

Webster County, Nebraska

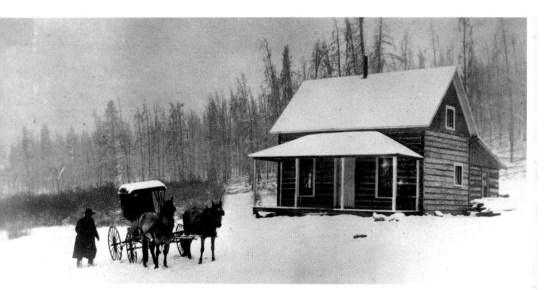

Near Cheyenne, Wyoming, circa 1910

*A*t nights when I wake up and hear the wind shrieking, I almost fancy there is too much sail on the house, & I had better go on the roof and rig in the chimney.

—*from a letter (1850) by Herman Melville*

The house was full of the sound of the gale. It was a winter north-easter, furious with wind and snow, and driving down against us from the dark and desolate North Atlantic and a thousand miles of whitecaps and slavering foam. Wailings and whistling cries, ghostly sighings under latched doors, fierce pushings and buffetings of the exposed walls—thrusts one could feel as a vibration of the house itself—all these had something of their being in the sheltered and humanly-beautiful room. United with these, tumul-tuous and incessant, rose the higher aerial cry of the gale in space above the earth . . .

Timber and wall, the old, honest, well-built house resisted with its own defi-ance. It has closed with such storms for almost one hundred and fifty years, standing in its ancient fields as a fortress of the hopes of man and his will to live. An old farm is always more than the people under its roof. It is the past as well as the present, and vanished generations have built themselves into it as well as left their footsteps in the worn woodwork of the stair.

—*from* NORTHERN FARM *by Henry Beston*

110

Instantly he would see the town below now, coiling in a thousand fumes of homely smoke, now winking into a thousand points of friendly light its glorious small design, its aching, passionate assurances of walls, warmth, comfort, food, and love. It spoke to him of something deathless and invincible in the souls of men, like a small light in a most enormous dark that would not die. Then hope, hunger, longing, joy, a powerful desire to go down to the town again would fill his heart. For in the wild and stormy darkness of oncoming night there was no door, and the thought of staying there in the darkness on the mountain top was not to be endured.

Then his uncle and he would go down the mountain side, taking the shortest, steepest way they knew, rushing back down to the known limits of the town, the streets, the houses, and the lights, with a sense of furious haste, hairbreadth escape, as if the great beast of the dark was prowling on their very heels. When they got back into the town, the whole place would be alive with that foggy, smoky, immanent, and strangely exciting atmosphere of early Winter evening and the smells of supper from a hundred houses. The odors of the food were brawny, strong, and flavorsome, and proper to the Winter season, the bite and hunger of the sharp, strong air . . .

Thus the strong and homely fragrance of substantial food smells proper to the Winter evoked a thousand images of warmth, closed-in security, roaring fires, and misted windows, mellow with their cheerful light. The doors were shut, the windows were all closed, the houses were all living with that secret, golden, shut-in life of Winter, which somehow pierced the spirit of a passer-by with a wild and lonely joy, a powerful affection for man's life, which was so small a thing against the drowning horror of the night, the storm, and everlasting darkness, and yet which had the deathless fortitude to make a wall, to build a fire, to close a door.

The sight of these closed golden houses with their warmth of life awoke in him a bitter, poignant, strangely mixed emotion of exile and return, of loneliness and security, of being forever shut out from the palpable and passionate integument of life and fellowship, and of being so close to it that he could touch it with his hand, enter it by a door, possess it with a word—a word that, somehow, he could never speak, a door that, somehow, he would never open.

—*from* THE WEB AND THE ROCK *by Thomas Wolfe*

"*The country of our childhood survives, if only in our minds . . .*"

Glen Ridge, New Jersey

*W*herever it lies, the country is our own; its people speak our language, recognize our values, yes, and our grandmother's eyes, our uncle's trick of pausing in a discussion to make a point impressive. "The Hopkinses was alluz an arguin' family," they say, and suddenly you laugh with a feeling of tension relaxed and pretenses vanished. This is your home . . . but does it exist outside your memory? On reaching the hilltop or the bend in the road, will you find the people gone, the landscape altered, the hemlock trees cut down and only stumps, dried tree-tops, branches and fireweed where the woods had been? Or, if the country remains the same, will you find yourself so changed and uprooted that it refuses to take you back, to reincorporate you into its common life? No matter: the country of our childhood sur- vives, if only in our minds, and retains our loyalty even when casting us into exile . . .

—*from* EXILE'S RETURN *by Malcolm Cowley*

*H*ome is where you come when you run out of places.

—*Barbara Stanwyck as "May Doyle" in* CLASH BY NIGHT

*B*e not long away from home.

—*Homer*

A man travels the world over in search of what he needs and returns home to find it.

—*George Moore*

New Hope, Pennsylvania

Stability, origins, a sense of oneness, the first clearing in the woods—to go home may be impossible but it is often a driving necessity, or at least a compelling dream. As the heroes of romance beginning with Odysseus know, the route is full of turnings, wanderings, danger. To attempt to go home is to go the long way around, to stray and separate in the hope of finding completeness in reunion, freedom in reintegration with those left behind. In baseball, the journey begins at home, negotiates the twists and turns at first, and often founders far out at the edges of the ordered world at rocky second—the farthest point from home. Whoever remains out there is said to "die" on base. Home is finally beyond reach in a hostile world full of quirks and tricks and hostile folk . . .

And when it is given one to round third, a long journey seemingly over, the end in sight, then the hunger for home, the drive to rejoin one's earlier self and one's fellows, is a pressing, growing, screaming in the blood. Often the effort fails, the hunger is unsatisfied as the catcher bars fulfillment, as the umpire-father is too strong in his denial, as the impossibility of going home again is reenacted in what is often baseball's most violent physical confrontation, swift, savage, down in the dirt, nothing availing.

Or if the attempt, long in planning and execution, works, then the reunion and all it means is total—the runner is a returned hero, and the teammates are for an instant all true family. Until the attempt is tried again. A "home run" is the definitive kill, the overcoming of obstacle at one stroke, the gratification instantaneous in knowing one has earned a risk-free journey out, around, and back—a journey to be taken at a leisurely pace (but not too leisurely) so as to savor the freedom, the magical invulnerability, from denial or delay.

Virtually innumerable are the dangers, the faces of failure one can meet if one is fortunate enough even to leave home. Most efforts fail. Failure to achieve the first leg of the

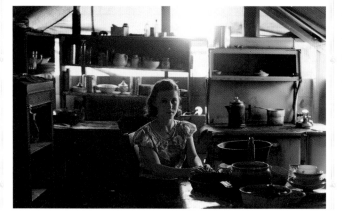

Yakima Valley, Washington, 1936

*H*omeward Bound

I wish I was,

Homeward Bound

Home where my
thought's escaping,

Home where my music's
playing,

Home where my love lies
waiting silently for me.

—*from* "HOMEWARD
BOUND" *by Paul Simon*

voyage is extremely likely.
In no game of ours is
failure so omnipresent as
it is for the batter who
would be the runner. The
young batter who would
light out from home, so
as to return bearing fame
and the spoils of success,
is most often simply out,

unable to leave and there-
fore never to know until
the next try whether he
or she can ever be more
than simply a vessel of
desire.

—*from* TAKE TIME FOR
PARADISE *by A. Bartlett
Giametti*

117

*M*id pleasures and palaces though we may roam,

Be it ever so humble, there's no place like home;

A charm from the sky seems to hallow us there,

Which, seek through the world, is ne'er met with elsewhere.

Home, home, sweet, sweet home!

There's no place like home, oh, there's no place like home!

An exile from home, splendor dazzles in vain;

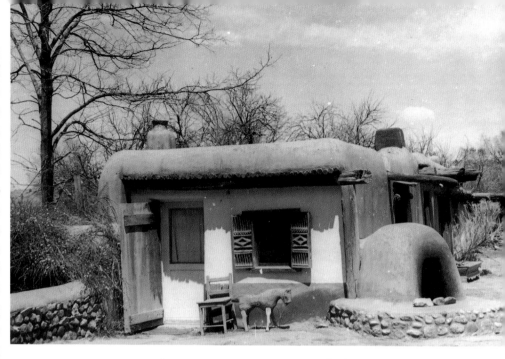

Santa Fe, New Mexico

Oh, give me my lowly thatched cottage again!

The birds singing gayly, that came at my call—

Give me them—and peace of mind, dearer than all!

Home, home, sweet, sweet home!

There's no place like home, oh, there's no place like home!

—*from* "HOME, SWEET HOME" *by John Howard Payne*

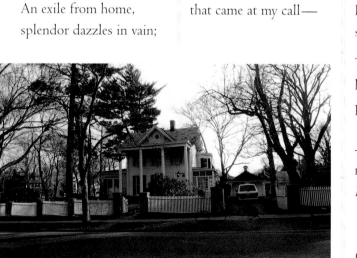

Glen Ridge, New Jersey

*T*hey are going home for Thanksgiving, traveling through the clogged arteries of airports and highways, bearing bridge chairs and serving plates, Port-a-Cribs and pies. They are going home to rooms that resound with old arguments and interruptions, to piano benches filled

with small cousins, to dining-room tables stretched out to the last leaf.

They no longer migrate over the river and through the woods straight into that Norman Rockwell poster: Freedom from Want. No, Thanksgiving isn't just a feast, but a reunion. It's no longer a celebration of food (which is plentiful in America) but of family (which is scarce).

Now families are so dispersed that it's easier to bring in the crops than the cousins. Now it's not so remarkable that we have a turkey to feed the family. It's more remarkable that there's enough family around to warrant a turkey.

For most of the year, we are a nation of individuals, all wrapped in separate cellophane packages like lamb chops in the meat department of a city supermarket. Increasingly we live with decreasing numbers. We create a new category like Single Householder, and fill it to the top of the Census Bureau reports.

For most of the year, we are segregated along generation lines into retirement villages and singles complexes, young married subdivisions and college dormitories, all exclusive clubs whose membership is defined by age . . .

The family—as extended as that dining-room table—may be the one social glue strong enough to withstand the centrifuge of special interests which send us spinning away from each other . . . Our families are not just the people (if I may massacre Robert Frost) who, "when you have to go there, they have to let you in." They are the people who maintain an unreasonable interest in each other. They are the natural peacemakers in the generation war.

"Home" is the only place in society where we now connect along the ages, like discs along the spine of society. The only place where we remember that we're all related. And that's not a bad idea to go home to.

—*from* "FAMILY: THE ONE SOCIAL GLUE" *by Ellen Goodman*

Saint Paul, Minnesota, circa 1905

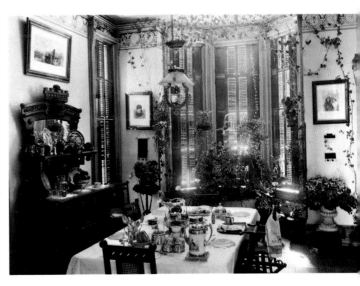

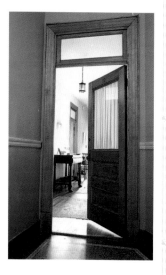

Washington, D.C.

*H*ome is the question you finally answer

Home is the hollow you finally fill

Simple and clear as the rain on the rooftop

Gentle and strong as the sun on the sill

Home is the habit you've never quite broken

Home is the hearth where you warm your soul

When everything 'round you is coming to pieces

Home is the place where your heart can feel whole

Home is a mansion that echoes with memories

Home is a room with a simple chair

Home is together and home is alone . . .

Home is the place that you'll know when you're there

Home is the place that you'll know . . . when you're there

—"HOME" *by Shelley Miller*

Boston, Massachusetts

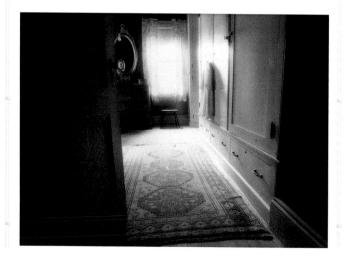

West Tisbury, Massachusetts

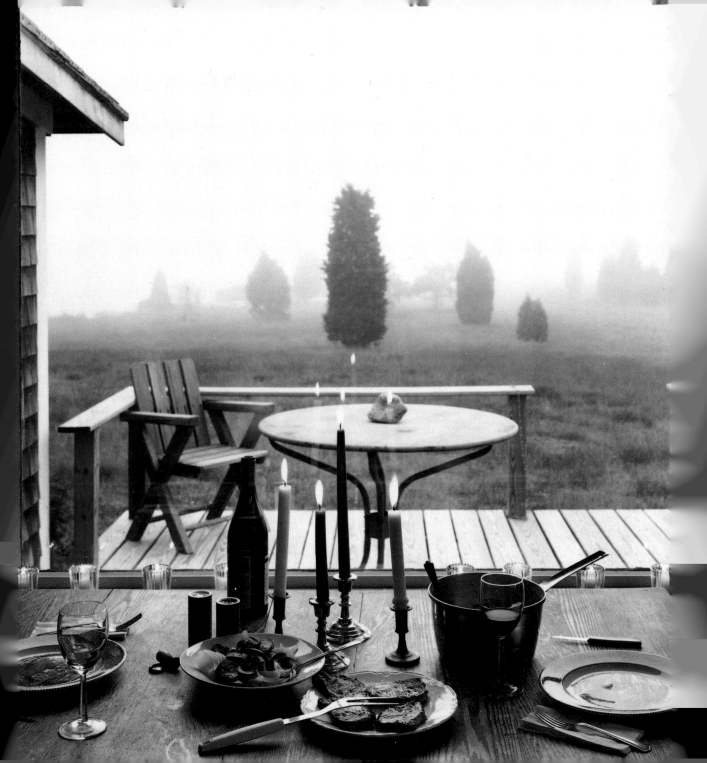

*G*randma, at eighty, is still a tramp at heart. A few summers ago she set out for a vacation in her old hometown many miles away. Her friends are nearly all dead and some that aren't are getting deaf and feeble, a strange fact that Grandma can't understand. In her native village she went to the house in which she was born and grew up. With a perverse insistence but undeniable decorum, she got the present owner, a complete stranger, to rent her her old room, and now each summer she goes there to live things over and over again. "I feel so much at home there," she says, "it makes me remember so many things and people."

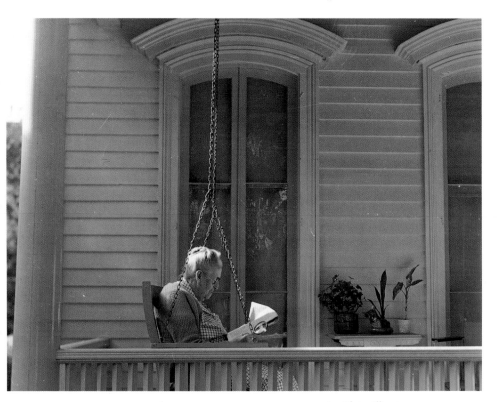

Elgin, Illinois, 1941

Which, when you come right down to it, is the finest purpose of a home.

—*from* JUST AND DURABLE PARENTS *by James Lee Ellenwood*

*B*eyond this final house

I'll make no journeys,
that is

the nature of this place,

I came here old; the
house contains

the shade of its walls

a fire in winter; I know

from what direction to
expect the wind;

still
 I move in the descent

Brookline, Massachusetts

of days from what was
dreamed

to what remains.

In the stillness of this
single place

where I'm resigned to die

I'm not free of journeys:

one eye watches while the
other sleeps

— every day is a day's
remove

from what I knew.

—*from "*BOONE*"*
by Wendell Berry

*T*he weary Mole also was glad to turn in without delay, and soon had his head on his pillow, in great joy and contentment. But ere he closed his eyes he let them wander round his old room, mellow in the glow of the firelight that played or rested on familiar and friendly things which had long been unconsciously a part of him, and now smilingly received him back, without rancour . . . He saw clearly how plain and simple—how narrow, even—it all was; but clearly, too, how much it all meant to him, and the special value of some such anchorage in one's existence. He did not at all want to abandon the new life and its splendid spaces, to turn his back on sun and air and all they offered him and creep home and stay there; the upper world was all too strong, it called to him still, even down there, and he knew he must return to the larger stage. But it was good to think he had this to come back to, this place which was all his own, these things which were so glad to see him again and could always be counted upon for the same simple welcome.

—*from* THE WIND IN THE WILLOWS *by Kenneth Grahame*

*I*f I ever go looking for my heart's desire again, I won't look any further than my own backyard; because if it isn't there, I never really lost it to begin with! . . . and I'm not going to leave here ever, ever again, because I love you all! And . . . oh, Auntie Em, there's no place like home!

—*Judy Garland as "Dorothy" in* THE WIZARD OF OZ

Port Clyde, Maine

CREDITS

TEXT

Sherwood Anderson: Excerpt from *Tar: A Midwest Childhood*, copyright 1926 by Boni & Liveright. Copyright renewed 1954 by Eleanor Copenhaver Anderson. Reprinted by permission of Harold Ober Associates Incorporated.

Maya Angelou: Excerpt from *All God's Children Need Traveling Shoes*. Reprinted by permission of Random House, Inc.

Dave Barry: Excerpt from *Dave Barry's Guide to Marriage and/or Sex*. Copyright © 1987 by Dave Barry. Reprinted by permission of Rodale Press, Inc., Emmaus, Pa.

Marvin Bell: "Her Dream House" from *A Probable Volume of Dreams*, Atheneum, 1969. Copyright © 1969 by Marvin Bell. Reprinted by permission of the author.

Wendell Berry: Excerpt from *The Unsettling of America: Culture and Agriculture*. Copyright © 1977 by Wendell Berry. Reprinted by permission of Sierra Club Books.

—Excerpt from "Boone" from *Collected Poems 1957–1982*. Copyright © 1984 by Wendell Berry. Reprinted by permission of North Point Press, a division of Farrar, Straus & Giroux, Inc.

Henry Beston: Excerpt from *Northern Farm*. Copyright © 1948 by Rinehart & Co. Reprinted by permission of Henry Holt & Company, Inc.

Anne Buttimer: Excerpt from "Home, Reach and Sense of Place" from *Human Experience of Space and Place*, edited by Anne Buttimer and David Seamon, Croom-Helm Limited. Reprinted by permission of the author.

Willa Cather: Excerpt from "The Best Years" from *Five Stories*. Reprinted by permission of Random House, Inc.

Colette: Excerpt from *Places*, translated by David Le Vay. Reprinted by permission of Peter Owen Publishers, London.

Laurie Colwin: Excerpts from *The Lone Pilgrim*. Copyright © 1981 by Alfred A. Knopf. Reprinted by permission of Random House, Inc.

Malcolm Cowley: Excerpt from *Exile's Return*. Copyright © 1934, 1935, 1941, 1951 by Malcolm Cowley. Reprinted by permission of Viking Penguin, a division of Penguin Books USA Inc.

Harry Crews: Excerpt from *A Childhood: the biography of a place*. Copyright © 1978 by Harry Crews. Reprinted by permission of John Hawkins & Associates, Inc.

Eric Dardel: Excerpt from *Mankind and the Earth* (*L'Homme et La Terre: Nature de Realité Géographique*). Copyright 1952 by Presses Universites de France, Paris.

Jane Davison: Excerpt from *The Fall of a Doll's House*. Reprinted by permission of Henry Holt & Company, Inc.

Flavia Robinson Derossi: Excerpt from "Eyes and Lashes." Reprinted by permission of the Director of the Bertha Urdang Gallery.

Annie Dillard: Excerpt from *An American Childhood*. Copyright © 1987 by Annie Dillard. Reprinted by permission of HarperCollins Publishers, Inc.

James Lee Ellenwood: Excerpt from *Just and Durable Parents*. Copyright 1949 by Charles Scribner's Sons. Reprinted by permission of Judson Ellenwood.

Erik H. Erikson: Excerpt from *Insight and Responsibility*. Copyright © 1964 by Erik H. Erikson. Reprinted by permission of W. W. Norton & Company, Inc.

E. M. Forster: Excerpts from *Howards End*. Reprinted by permission of Random House, Inc.

Robert Frost: Excerpt from "The Death of the Hired Man" in *North of Boston*, Henry Holt & Company, 1914. Reprinted by permission of Henry Holt & Company, Inc.

A. Bartlett Giamatti: *Take Time for Paradise*. Copyright © 1989 by the estate of A. Bartlett Giamatti. Reprinted by permission of Mildred Marmur Associates Ltd.

Nikki Giovanni: Excerpt from *Sacred Cows . . . and Other Edibles*. Copyright © 1988 by Nikki Giovanni. Reprinted by permission of William Morrow & Company, Inc.

Ellen Goodman: Excerpt from "Family: The One Social Glue" in *Close to Home*. Copyright © 1979 by The Washington Post Co. Reprinted by permission of Summit, a division of Simon & Schuster, Inc.

Allan Gurganus: Excerpts from "Storied Objects" in *HG Magazine*, May, 1989, copyright © Allan Gurganus and Condé Nast. Reprinted by permission of the author.

Martin Heidegger: Excerpt from "Building Dwelling Thinking" in *Basic Writings*. English translation copyright © 1977 by Harper & Row, Publishers, Inc. General introduction and introductions to each selection copyright © 1977 by David Farrell Krell. Reprinted by permission of HarperCollins Publishers, Inc.

William Humphrey: Excerpts from *Farther Off from Heaven*, Alfred A. Knopf. Reprinted by permission of the author.

Josephine Humphreys: Excerpt from *Dreams of Sleep*. Copyright © 1984 by Josephine Humphreys. Reprinted by permission of Penguin Books USA, a division of Penguin Books USA Inc.

Christopher Isherwood: Excerpt from *A Single Man*. Copyright © 1964 by Christopher Isherwood. Copyright renewed © 1992 by Don Bachardy. Reprinted by permission of Farrar, Straus & Giroux, Inc.

Shirley Jackson: Excerpt from "Elizabeth" in *The Lottery*. Copyright © 1948, 1949 by Shirley Jackson and copyright renewed © 1976, 1977 by Laurence Hyman, Barry Hyman, Mrs. Sarah Webster, and Mrs. Joanne Schnurer. Reprinted by permission of Farrar, Straus & Giroux, Inc.

Storm Jameson: Excerpt from *Journey from the North*, copyright the Estate of Storm Jameson. Reprinted by permission of Peters, Fraser & Dunlop, London.

Robinson Jeffers: Excerpt from *Selected Letters of Robinson Jeffers*, edited by Ann N. Ridgeway. Reprinted by permission of Ann N. Ridgeway.

Elizabeth Kaye: Excerpt from "Sly's Progress," *Esquire*, February, 1989, copyright © 1989 by Elizabeth Kaye. Reprinted by permission of *Esquire* and the Hearst Corporation.

Alfred Kazin: Excerpt from *A Walker in the City*, copyright 1951 and renewed 1979 by Alfred Kazin. Reprinted by permission of Harcourt Brace & Company.

Garrison Keillor: Excerpt from "O the Porch" copyright © 1982, 1989, by Garrison Keillor. From *We Are Still Married: Stories and Letters*. Reprinted by permission of Viking Penguin, a division of Penguin Books USA Inc.

William Kittredge: Excerpt from "The Soap Bear" copyright 1984 by William Kittredge. From *We Are Not in This Together*. Reprinted by permission of Graywolf Press.

Spiro Kostof: Excerpt from *America by Design*. Copyright © 1987 by Oxford University Press. Reprinted by permission of Oxford University Press.

John Leonard: Excerpt from *Private Lives in the Imperial City*, Alfred A. Knopf, 1979. Reprinted by permission of Random House, Inc.

Nancy Mairs: Excerpts from *Remembering the Bone House*. Copyright © 1989 by Nancy Mairs. Reprinted by permission of HarperCollins Publishers, Inc.

Shelley Miller, "Home." Copyright © 1981 by Shelley Miller. Reprinted by permission of the author.

Lorrie Moore: Excerpt from *Anagrams*. Copyright © 1986 by Alfred A. Knopf. Reprinted by permission of Random House, Inc.

Jan Morris: Excerpt from *Pleasures of a Tangled Life*. Copyright © 1989 by Jan Morris. Reprinted by permission of Random House, Inc.

Lewis Mumford: Excerpts from *The Myth of the Machine: Technics and Human Development*. Copyright © 1967 by Lewis Mumford. Reprinted by permission of Harcourt Brace & Company.

—*My Works and Days: A Personal Chronicle*. Copyright © 1979 by Harcourt Brace & Company. Reprinted by permission of Harcourt Brace & Company.

Joyce Carol Oates: Excerpts from "Princeton Pastoral" in *HG Magazine*, June, 1990, copyright © The Ontario Review, Inc., 1990. Reprinted by permission of the author.

David Owen: Excerpt from *The Walls Around Us: The Thinking Person's Guide to How a House Works*. Copyright by Villard Books. Reprinted by permission of Random House, Inc.

Sylvia Plath: Excerpt from *Letters Home by Sylvia Plath: Correspondence 1950–1963* by Aurelia Schober Plath. Copyright © 1975 by Aurelia Schober Plath. Reprinted by permission of HarperCollins Publishers, Inc.

Katherine Anne Porter: Excerpt from "A House of My Own" in *The Complete Essays and Occasional Writings of Katherine Anne Porter.* Copyright © 1970 by Katherine Anne Porter. Reprinted by permission of Houghton Mifflin Company/Seymour Lawrence. All rights reserved.

Marjorie Kinnan Rawlings: Excerpt from *Cross Creek.* Copyright 1942 by Marjorie Kinnan Rawlings; copyright renewed © 1970 by Norton Baskin. Reprinted by permission of Charles Scribner's Sons, an imprint of Macmillan Publishing.

E. Relph: Excerpt from *Place and Placelessness,* 1976, Pion Limited, London. Reprinted by the permission of the author and Pion Limited.

Adrienne Rich: "Moving In Winter" from *The Fact of a Doorframe: Poems Selected and New 1950–1984.* Copyright © 1984 by Adrienne Rich. Reprinted with the permission of W. W. Norton & Company, Inc.

Witold Rybczynski: Excerpts from *Home: A Short History of an Idea.* Copyright © 1986 by Witold Rybczynski. Reprinted by permission of Viking Penguin, a division of Penguin Books USA Inc.

—"Home, Sweet Bungalow Home" originally published in *Wigwag Magazine,* October, 1986, copyright Witold Rybczynski. Reprinted by permission of the author.

—Excerpt from *The Most Beautiful House in the World.* Copyright © 1989 by Witold Rybczynski. Reprinted by permission of Viking Penguin, a division of Penguin Books USA Inc.

Vita Sackville-West: Excerpts from *The Edwardians* and *Heritage* reprinted by permission of Nigel Nicolson, executor of the estate of V. Sackville-West.

May Sarton: Excerpt from *Mrs. Stevens Hears the Mermaids Singing.* Copyright © 1965 by May Sarton. Reprinted with the permission of W. W. Norton & Company, Inc.

Sam Shepard: Excerpt from "True West," copyright © 1981 by Sam Shepard, in *Seven Plays.* Reprinted by permission of Bantam Books, a division of Bantam Doubleday Dell Publishing Group, Inc.

Paul Simon: Excerpt from "Homeward Bound." Copyright © 1966. Copyright renewed Paul Simon. Reprinted by permission of the publisher.

Page Smith: Excerpt from *Daughters of the Promised Land.* Reprinted by permission of Little, Brown and Company.

David E. Sopher: "The Structuring of Space in Place Names and Words for Place" reprinted from *Humanistic Geography,* edited by David Ley and Marwyn S. Samuels, Maaroufa Press, 1978. Reprinted by permission of Teresa L. Sopher (Mrs. David Sopher).

Ettore Sottsass: Excerpt from "Why the Home-as-Castle Isn't What It Used to Be" by Roberto Suro, from *The New York Times.* Copyright © 1988 by The New York Times Company. Reprinted by permission of The New York Times Company.

Kim R. Stafford: Excerpt from "The Separate Hearth," copyright by Kim Stafford. From *Having Everything Right,* Confluence Press, Lewiston, Idaho, 1986. Reprinted by permission of Confluence Press.

John Steinbeck: Excerpt from *The Grapes of Wrath.* Copyright 1939, renewed © 1967 by John Steinbeck. Reprinted by permission of Viking Penguin, a division of Penguin Books USA Inc.

Robert A. M. Stern: Excerpt from *Pride of Place.* Copyright © 1986 by Mobil Corporation, Malone Gill Productions Limited and Robert A. M. Stern. Reprinted by permission of Houghton Mifflin Company. All rights reserved.

Barbara Ward: Excerpt from *The Home of Man.* Copyright © 1976 by the International Institute for Environment and Development. Reprinted by permission of W. W. Norton & Company, Inc.

Simone Weil: Excerpt from *The Need for Roots: Prelude to a Declaration of Duties Towards Mankind.* Copyright 1951, 1980 by G. P. Putnam's Sons. Reprinted with permission of Editions Gallimard, Paris.

Peter Weiss: Excerpt from *Exile* reprinted by permission of Suhrkamp Verlag, Frankfurt am Main.

Linda Weltner: Excerpt from *No Place Like Home.* Copyright © 1988 by Linda Weltner. Reprinted by permission of William Morrow & Company, Inc.

Eudora Welty: Excerpt from "The Little Store" in *The Eye of the Story.* Reprinted by permission of Random House, Inc.

Jessamyn West: Excerpt from *Hide and Seek: A Continuing Journey.* Copyright © 1973 by Jessamyn West. Reprinted by permission of Harcourt Brace & Company.

E. B. White: Excerpt from "Removal" from *One Man's Meat.* Copyright © 1938, copyright renewed 1966 by E. B. White. Reprinted by permission of HarperCollins Publishers, Inc.

The Wizard of Oz. Excerpt reprinted by permission. © 1939. Turner Entertainment Co. All Rights Reserved.

Thomas Wolfe: Excerpt from *The Web and the Rock.* Copyright © 1937, 1938, 1939 by Maxwell Perkins as the Executor of the Estate of Thomas Wolfe. Copyright renewed 1965 by Paul Gitlin, C.T.A./ Administrator of the Estate of Thomas Wolfe. Reprinted by permission of HarperCollins Publishers, Inc.

John Updike: Excerpts from *Self-Consciousness.* Copyright © 1989 by John Updike. Reprinted by permission of Alfred A. Knopf.

PHOTOGRAPHS

American Heritage Center, University of Wyoming, 20

Nathaniel Antman, 39, 106, 108 (left)

Reenie Schmerl Barrow, 61, 124

David Briggs, 99

Brooklyn Historical Society, 73

Philip A. Burzynski, i, 1, 86

Carnegie Library of Pittsburgh, 81

Colorado Historical Society, 11, 44, 67, 90, 91

Stephen DiRado, 121

Florida Department of Commerce, Division of Tourism, 34 (both)

FPG International, Paul L. Mathews, 28

Dede Hatch, 68 (left), 117

Historic New Orleans Collection, Charles John Laughlin (1983.47.4.856), 80

Historical Society of Pennsylvania, 12

Idaho State Historical Society, 38, 53

Library of Congress, 26; John Vachon, 35, 122; Russell Lee, 47, 72; Walker Evans, 60; Dorothea Lange, 22–23, 71; Marion Post Wolcott, 78–79; Arthur Rothstein, 116

Minnesota Historical Society, 41, 56, 63, 77, 102, 119; H. L. Renne, 23

Rollie McKenna, 66

Cheryl Moch, 59 (both), 85 (left), 112–13, 118 (left)

Abelardo Morell, Courtesy of the photographer and Bonni Benrubi Gallery, New York, iii, 9, 13, 31, 51, 88, 89, 123

Museum of History and Industry, Seattle, Washington, Pemco Webster & Stevens Collection, 2–3, 25, 37 (both)

Museum of New Mexico, Palace of the Governors, 76, 118 (right); Karl Kernberger, 57

National Gallery of Art, The Goode-Phillips Collection, James Tetro, 30, 83; James Phillips, 75, 120 (left)

Nebraska State Historical Society, 4, 7, 16–17, 40, 42, 54–55, 62, 68 (right), 85 (right), 105, endpapers; Butcher Collection, 27; Willa Cather Pioneer Memorial Collection, 109; MacDonald Studio Collection, 19, 46 (left), 48, 64, 84, 95, 98

Patricia D. Richards, 10, 104, 107

Nancy P. Roberts, 29, 120 (right)

Carol Ross, 18, 114–15, 115

San Diego Historical Society, Photographic Collection, 58 (left), 70, 100

Julius Shulman, 5, 21, 32–33, 46 (right), 65, 74, 96–97, 101

Society for the Preservation of New England Antiquities, 24 (left), 52, 92

State Historical Society of Wisconsin, 6, 8, 14–15, 17, 93

The Mark Twain House, 102, 103

University of Louisville, Photographic Archives, Caufield & Shook Collection, iv–v, 49, 94; R. G. Potter Collection, 43, 45

Walden Pond State Reservation, Department of Environmental Management, Division of Forests and Parks, 69

Laine Whitcomb, 24 (right), 36, 57 (left), 58 (right), 108 (right)

Wyoming State Museum, 110

INDEX

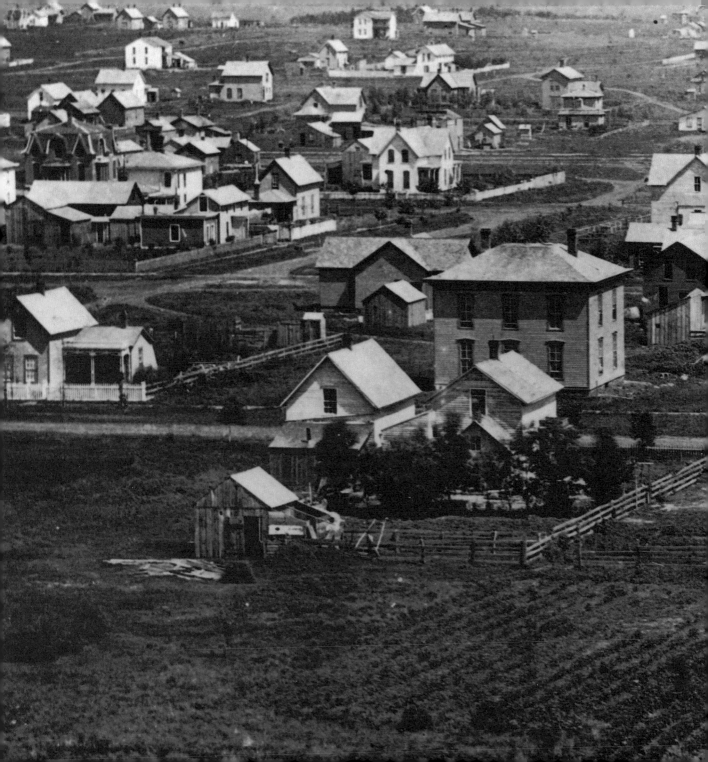